SECRET HORSHAM

Maggie Weir-Wilson

About the Author

Dr Maggie Weir-Wilson started her working life in a variety of clerical and secretarial roles in London and later in Wiltshire and Kent. Bored with this work, she began an Open University degree course and enjoyed the whole academic experience. She followed her Open University BA with a University of Kent MA in Social Work, CQSW, in addition to volunteering with young people in trouble. Thus, followed a long career as a Probation Officer in Kent and Sussex, specialising in practice teaching. She moved to Horsham in 2000 and loved the surrounding Wealden landscape so started evening study at the University of Sussex gaining a First BA (Hons) in Landscape Studies. With retirement looming what else was there to do but return to the University of Sussex and take a DPhil in Landscape History, looking at the historical landscape development of St Leonard's Forest. Now, Maggie continues to write local history, as well as writing poetry and stories. She also enjoys botanical painting and working on her allotment at Chesworth Allotments.

First published 2019

Amberley Publishing
The Hill, Stroud
Gloucestershire, GL5 4EP

www.amberley-books.com

Copyright © Maggie Weir-Wilson, 2019

The right of Maggie Weir-Wilson to be identified as the Author of this work has been asserted in accordance with the Copyrights, Designs and Patents Act 1988.

ISBN 978 1 4456 8645 5 (print)
ISBN 978 1 4456 8646 2 (ebook)

All rights reserved. No part of this book may be reprinted or reproduced or utilised in any form or by any electronic, mechanical or other means, now known or hereafter invented, including photocopying and recording, or in any information storage or retrieval system, without the permission in writing from the Publishers.

British Library Cataloguing in Publication Data.
A catalogue record for this book is available from the British Library.

Origination by Amberley Publishing.
Printed in Great Britain.

Contents

	Introduction	4
1.	Early Beginnings	5
2.	Markets and Fairs	15
3.	Industry and Trade	24
4.	Forest and Commons	37
5.	Myths and Legends	48
6.	Arts and Culture	57
7.	Crime and Punishment	71
8.	War and Peace	83
	Bibliography	95
	Acknowledgements	96

Introduction

Long-term Horsham locals will be familiar with many of the 'secrets' in this book but there are many new residents discovering Horsham for the first time. The town has a fascinating and rich story to tell, so here is a swift history of secret Horsham. All the brilliant men and women who have passed through. How the town began, the markets, the breweries, the fairs and the fun, as well as the darker side of crime and war. Horsham has a lot to shout about, so let's start at the beginning.

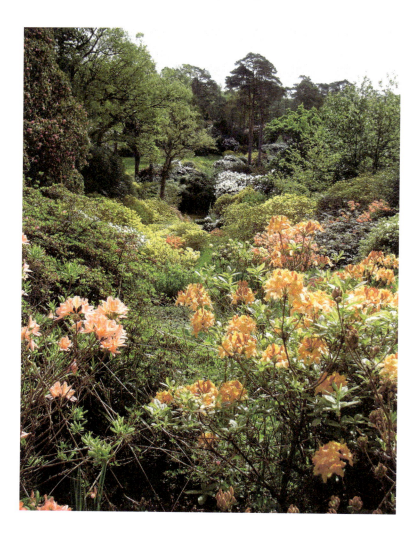

1. Early Beginnings

The oldest rocks in Sussex were laid down at the end of the Jurassic Period in shallow water around 140 million years ago. In the later Cretaceous Period, 60 to 50 million years ago, came the silts, sands and ironstone-rich clays. From this time comes the famous

Horsham stone roof tiles on the seventeenth-century Blue Idol meeting house, Coolham. (With thanks to West Weald Quaker Area Meeting)

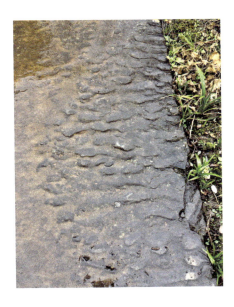

Ripple stone in the path leading up to the Horsham Friends Meeting House. (With thanks to West Weald Quaker Area Meeting)

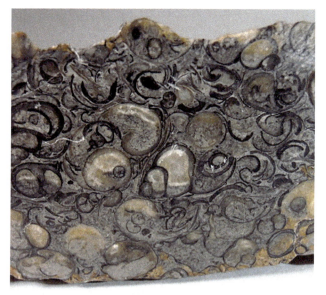 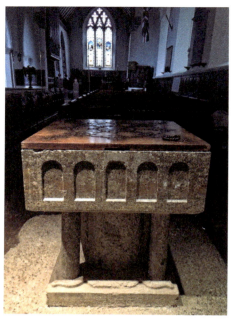

Above left: Example of Sussex marble from Petworth. (© www.therockgallery.co.uk)

Above right: Twelfth-century font made of Sussex marble at Holy Trinity Church, Rudgwick. (With kind permission from Revd Martin King)

Horsham stone, used since the early Middle Ages for roof tiles and paving slabs. The sharp-eyed can identify ripples like those on a sandy beach formed in shallow seas and preserved in the hard sandstone. Also from this period comes Sussex marble, or Paludina limestone, a lovely green-coloured stone packed with freshwater fossil shells, which was in demand for church altars and fonts, house pillars and fireplaces.

Mantell, Fossils and Our Horshamosaur

In the shallow seas and warm climate of around 100 million years ago dinosaurs, such as the iguanodons, crocodiles and large dragonflies, stomped and buzzed around Horsham. In 1822 Gideon Mantell, surgeon and palaeontologist from Brighton, was the first to publish theories on his finds of fossil teeth from Tilgate Forest and Cuckfield, just to the east of Horsham. Poor Mantell came in for a lot of criticism from the wealthy scientists of the day, who derided his theory of large lizards and could not believe such things had existed, and certainly not in the soil layers he found them in.

Nowadays, Mantell is known and celebrated for his vision and perseverance. Less well known is the work of the Horsham Quaker George Bax Holmes, who inherited money, and focussed on fossil finding, collecting from Mantell's rich quarry site in Tilgate Forest, and other areas such as Southwater. Holmes was cultivated by Mantell's rival, Richard Owen, who, as the friendship grew between Owen and Holmes, was given complete access to his growing collection, and information about Mantell's research.

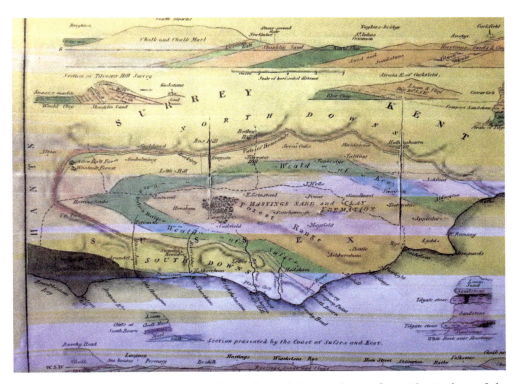

Part of map and sections illustrating the geology of the South East from *The Geology of the South-East of England* by Gideon Mantell, London, 1833.

Holmes found iguanodons – the great Horsham iguanodon in a field behind North Street and another on the road to New Lodge in the forest. He also found pterodactyl, Plesiosaurus, large amphibious reptiles, fishes and insects. Much of the research was appropriated by Richard Owen, who published in the 1840s, and eventually managed to alienate not only Holmes and Mantell but also other scientists in the field by his arrogance and jealously. Mantell died in November 1852 and shortly afterwards plans were being made by Owen for a full-sized model of the Horsham iguanodon to be displayed at the Crystal Palace at Sydenham. Somewhat bizarrely, the public opening of this model was an invitation to twenty-one distinguished guests to partake of a banquet set in the belly of the beast on New Year's Eve 1853. By this time dinosaur enthusiasm had taken off.

Subsequently, it appeared from more fossil remains that the iguanodon was the most common dinosaur in the south-east. In 1925 their fossil bones were found in Southwater village, as well as in 1928 and 1940 in the local brickworks. This site is now Southwater Country Park and a sculpture of an iguanodon, or Iggy as he is locally known, by sculptor Hannah Stewart now stands in the middle of Lintot Square, Southwater.

A more up-to-date find occurred in 1985 when the bone of what was thought to be a Polacanthus, a four-legged armoured plant eater, was unearthed by a digger at Rudgwick brickworks, north Horsham. More bones and evidence of dragonflies were unearthed by amateur archaeologist Mrs Sylvia Standing with helpers. The bones were eventually

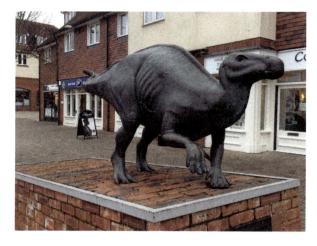

The iguanodon sculpture by Hannah Stewart at Lintot Square, Southwater.

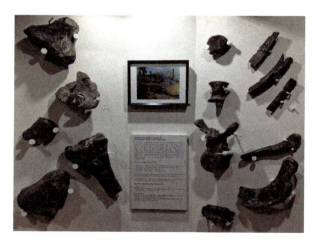

Bones of Horsham's unique dinosaur on display at Horsham Museum & Art Gallery. (Horsham District Council)

identified by William Blows palaeontologist working with the Natural History Museum as a new species of Polacanthus. Later research, again by Blows in 2015, caused him to think the fossil bones were not in fact from a Polacanthus but a completely new type of dinosaur that he then named 'Horshamosaur Rudwickensis'.

So, what is so unique about our Horshamosaur? The bones are of a different shape to the Polacanthus, it is 30 per cent larger and it has body armour, or bony plates, on the outside. All these fossils are on display in Horsham Museum, which is appropriate, as Holmes lived next door to what is now the museum in the Causeway.

The geological regions of the Sussex Downs and Weald are complex, hence the early difficulties of making out the age of the various strata. If one first imagines a huge chalk dome lying over Sussex, then in time the top of the dome erodes, leaving the great chalk rim of the North and South Downs. Remaining in the middle was the sandstone and clays of the Weald. Horsham lies on the western edge of the High Weald, a natural region of flat-topped ridges and deep wet valleys or ghylls.

A forest ghyll in St Leonard's Forest.

Early Horsham Culture

Earliest evidence of human presence in the landscape of Horsham dates from the Mesolithic period, or early Middle Stone Age, which in northern Europe is from around 10000 to 4000 BCE. Evidence is thanks to the wide interests and activities of Horsham's own nineteenth-century Renaissance man: Thomas Honywood.

Honywood was a wealthy property owner and captain of the volunteer fire brigade, which he set up himself. He was also an early pioneer in photography, having invented a new type of nature photography that was able to capture pictures of feathers or plants. It was so new and innovative that in 1885 he took a stand at the International Inventions Exhibition at the Royal Albert Hall, London. If this was not enough, he also had an abiding interest in archaeology and explored in St Leonard's Forest, on the eastern edge of town. He found lots of flint chippings, arrowheads, knives and spearheads, along with small microliths. He found evidence of burnt earth and charcoal but no bones of humans in the light sand and loam. He found time to write, draw and publish his findings and also to set up a home museum of all his curiosities.

Honywood's collection remains important, as later examination of it identified a very distinct way of working flint by hollowing out the base of each individual point or microlith, a small pointed flint. These are now known as Horsham Points and represent a particular archaeological culture known as Horsham culture not found elsewhere in Europe. This first truly British culture developed due to the separation of people from the Continent by the megafloods of the English Channel at the end of the Ice Age.

Further discoveries of scrapers, axes, arrowheads and flint flakes have been found throughout the district of Southwater. The Mesolithic period clearly saw the earliest Horsham inhabitants. Although they would have set up seasonal camps, they would also have been on the move as hunter-gatherers, moving north from the coastal areas into open mixed forest, which offered different opportunities. Evidence of Horsham's oldest known person is a skull dating from 1600 BCE and found in Cricket Field Road in the 1930s.

Two bronze axe heads were found by workmen at Hammer Farm in Billingshurst in the 1870s; they were recognised and rescued by Honywood before they were sold for scrap.

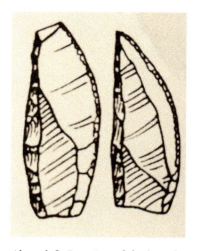 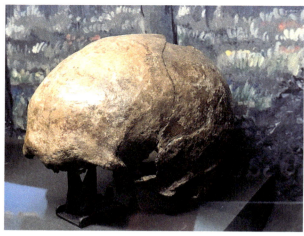

Above left: Drawing of the 'Horsham Point' flints by Dom Andrews. (© Horsham Museum & Art Gallery (Horsham District Council))

Above right: Skull dating from 1600 BCE found in Cricket Field Road and on display at Horsham Museum & Art Gallery. (Horsham District Council)

An Iron Age loom weight for weaving was found at Chesworth Farm by the River Arun, perhaps indicating the beginnings of an earlier settlement at Horsham.

Archaeological investigations tend to be concentrated on the chalk hills and coastal strip of Sussex. The Weald was thought to be thickly wooded and lacking in archaeological interest, however, we now know differently. From 2008 to 2014 investigations were undertaken at Wickhurst Green, south-east of Broadbridge Heath, near the A24, thanks to developer funding from Countryside Properties. This dig proved the presence of Mesolithic hunter-gatherers, Iron Age farmers, and Roman agriculture and industry. For example, evidence was found for a group of four roundhouses, posts and gullies with fragments of pottery, charcoal and kilns, and a possible grain store. Thus, it is now thought there was a Middle Iron Age settlement at Wickhurst Green.

DID YOU KNOW?

The name Horsham, the spelling of which has remained constant over the millennium, is derived from the Saxon for a horses' home, where they are bred. Other fanciful suggestions are that it was named after the Saxon horse god, or chieftain, called Horsa. Or that the mud was so awful in the town that it came up to horses' hams, or flanks. Alternatively, Horsham was named because so many iron horseshoes were made in the town for Edward I's armies. However, a place of horses is the accepted derivation now.

The Romans Arrive

The Romans invaded Kent in 54 BCE under Caesar. They met resistance on the battlefield but began a hundred years of getting to know the tribes of the south-east coastal regions through trade and cultural exchange until a final invasion proved successful in AD 43. This was probably launched through Sussex, although this is disputed. The next 400 years of occupation produced dramatic changes in the social, economic and technological development of Britain. The Sussex region was friendly to the Romans due to becoming an early client kingdom ruled initially by Togidubnus, a tribal leader who was loyal to Rome. Chichester was established in the first century CE and a number of large wealthy villas were built in the countryside, such as those at Fishbourne, Angmering and Bignor. These were followed by farms on the coastal strip and downs, which attracted settlement around them. The Roman Stane Street, today the A29, was constructed from Chichester to London early in the occupation, in AD 60–70. It went straight past Horsham, 5 miles to the west. It crossed the Arun at Hardham, near Pulborough with a posting station here and at Alfodean (investigated by the *Time Team* in 2005), thus forming small settlements for weary travellers.

It was thought that the Romans disregarded Horsham as a settlement and only regarded the forest as useful for its resources. However, in the 1960s a Roman quern stone for grinding grain was turned up by the GPO when laying telephone cables near Hills Place on the Guildford Road. Later in the same area a pit dated to the Roman period produced a variety of interesting pottery shards. The indication was of Roman occupation, perhaps a villa or farmstead, but the area was not thoroughly excavated and was built over in the 1980s. A missed opportunity.

Stane Street, or A29, from the crossroads at A281.

Next, it's the Saxons

It is generally accepted that the Romans left Britain in AD 410 to defend their homeland. Britannia was left to its own devices and was subsequently subjected to overseas raids by the Saxons from northern Germany. Although evidence for this period is scarce, it can be seen from looking at archaeological fragments that the change from Romano-British culture to Anglo-Saxon culture was slow, and by assimilation rather than sudden conquest. Evidence suggests that Saxon mercenaries had been used by the Romans to protect southern Britain and were living in mercenary settlements. The capture of a fort at Pevensey by the Saxon warrior Aelle in AD 491 led to him becoming the first King of the South Saxons in Britain.

Although the Romans were a hard act to follow, the Saxons established a good basis of administration by focussing certain tasks in distributing land and in Sussex dividing into manageable slices called 'Rapes'. These were then subdivided into 'Hundreds' for taxation, administration and justice. Large landed estates were also established for farming and the moving of herds from pastures to woodland in summer. Clearly, this opened up the Weald, and places like Steyning with woods and streams would have gained a small population.

The county was one of the last to go largely Christian, converted in part by Wilfred, Bishop of York, in missionary exile to Selsey on the south coast of Sussex. Churches, chapels and larger minsters began to be built in the centre of estates. Although many have now been lost, an example of a church with a solid Saxon heritage is St Andrew's at Steyning, to the south of Horsham. Although much of the architecture is Norman, it replaced the earlier wooden Saxon church and part of a monastery, established by the eighth-century Celtic shepherd-saint Cuthman. It is said that Cuthman came here from the West Country, pushing his mother before him in a wicker wheelbarrow and only a breakdown of this barrow in Steyning encouraged him to stay. He interpreted the broken barrow as a sign from God that this was a good place to settle. King Ethelwulf, father of King Alfred the Great, was buried at Steyning, although his body was later moved. His stone coffin lid bearing the royal symbol of two crosses can still be seen in the church, although some say the coffin lid belongs to Cuthman.

> **DID YOU KNOW?**
> Horsham's 'Birth Certificate' was the Charter of Washington AD 947 (so named by William Albery, a local historian who wrote *Millennium of Facts in the History of Horsham and Sussex 947–1947*) in which Eadred, King of Wessex, granted to Eadric, one of his loyal servants, lands within the boundaries of Washington. One of the areas or places named in the charter was Horsham. This is the first recorded mention of Horsham.

A parish of Horsham had been established in Saxon times. The parish is first mentioned in a charter of 963, which records Crockhurst as being in the parish of Horsham. There is the remains of a Norman arch near the parish church of St Mary the Virgin in the Causeway, and possibly there was an earlier wooden church before being rebuilt later in stone around 1231.

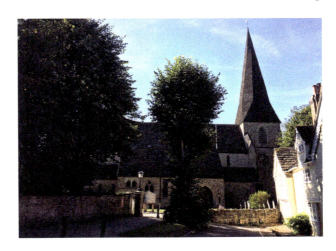

St Mary the Virgin Church, the Causeway, Horsham.

The Normans Invade

The end of the Saxon period came, of course, in 1066 when the Normans invaded through Sussex and William the Conqueror won at the Battle of Hastings, killing Saxon King Harold. The estates of the Saxon nobility were distributed among the new Norman aristocracy and the administrative areas altered. What had been Saxon Washington, including Horsham, became part of the Rape of Bramber and given by King William to one of his powerful knights, William de Braose. Each of the six rapes, or baronies, of Sussex included at least one town, a castle, a port and a forest. They ran from south to north, from the rich coastal plain into the forested and less populated Weald.

In 1086 the Domesday Book was undertaken. It was instigated by King William in order to record who owned what, and most importantly, what the taxable value would be. Although Horsham is not mentioned by name in the Domesday Book, it still falls into the Washington manor and the numbers of villagers, smallholders and ploughs for Washington included Horsham. It is also probable that the seventy pigs worth of woodland pasture in the survey was the forested areas around Horsham.

There is an interesting group of three old earthworks in north Horsham. The best known, and Horsham's only Scheduled Monument dating from the late eleventh century, is the motte and bailey just south of the A264, by Channells Brook and on the Riverside Walk. There is an entrance to the south and a courtyard, the bailey, to the west of the motte. The motte was an earthwork on which a wooden or stone tower was built. In addition, there was a large moat of around ten metres across, which may have used Channells Brook for water. This type of fortified keep was used for hunting and was effective in defence, and thus was popular with the Normans until they began to replace them with more substantial stone castles.

The other two earthworks are just north of the A264 and the above-mentioned motte and bailey. There is the Moated House Farm and the castle earthworks at Hawkesbourne Farm. It is possible that these moats were less defensive and more status driven. The late Ted Lee, whose father took on the tenancy of Moated House Farm in 1920, described it as set in a hollow at the end of a long winding flintstone lane, a beautifully proportioned

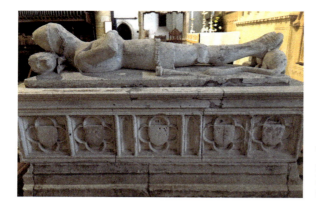

Tomb of the last of the de Braose family, Thomas de Braose. (With kind permission of St Mary's Church, Horsham)

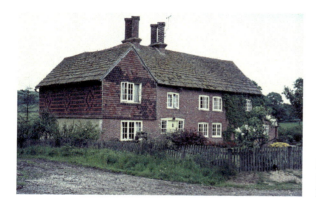

Moated House Farm in the 1960s. (With kind permission of Rowena Kirkpatrick, daughter of Ted Lee)

700-year-old farmhouse with four magnificent tall brick-built chimneys, roofed in Horsham stone and part hung with duotone clay tiles.

Horsham initially developed as a settlement due to its position on a north-south crossing of the River Arun, with plenty of freshwater streams rising in the forest but with higher, drier footpaths in the hills above. It was well placed to develop trading links between London and the coast and in this early period the Adur was navigable up to Bramber. It is thought the original centre of Horsham was somewhere near the crossroads of East Street and Denne Road, perhaps where the newsagent and Brewhouse and Kitchen are now. Trade was certainly growing and the de Braose family, who owned Washington manor, were keen to grant the town borough status, which was achieved around 1205/06. Sadly, borough status was lost in 1836 due to lazy administration.

The borough was laid out with fifty-two burgess plots, which were land within the borough. They paid a yearly rent to the lord of the manor, de Braose, and had a duty to run the borough and its markets. They were required to answer to the court baron, a private administrative court of the lord, and to the court leet, which dealt with misdemeanours and annually appointed a steward and two bailiffs. Horsham was now definitely on the map, and in the next chapter we look at how it developed into an important market town.

2. Markets and Fairs

Markets and fairs were particularly important in the development of Horsham. They were the main method of trade and the lifeblood of the town. Markets offered the opportunity to buy and sell goods, while fairs provided much-needed entertainment and relaxation, which in the medieval period was hard to come by, particularly for the less well-off.

The July Fair

The first to be given permission by the king was a three-day July market and fair around the time of the feast day of St Thomas. This royal charter was granted to William de Braose by Henry III in 1233. The three days could be extended to nine, depending on which day of the week 7 July fell, or 18 July when adjusted for the transfer from the Julian calendar to the Gregorian in 1750. The fair itself was held on undeveloped ground not owned by the borough's burgesses, to the north of the Causeway and East/West Street. This area was known as Scarfolkes, or later Carfax.

The July fair developed into a really important event both for traders and entertainers so the booths, stalls and tents extended their stay on the Carfax. Eventually this became more permanent, with leases and freeholds being granted. Originally the July fair was known for cattle and peddlery. Peddlers were door-to-door salesmen, useful in remote areas as they brought goods and services to people who otherwise would be unable to have these things. Peddlers would often buy up surplus stock at markets and fairs, selling it later as they did their rounds. They would station themselves on the edges of fairs, and the most extrovert would double as performers or fortune tellers.

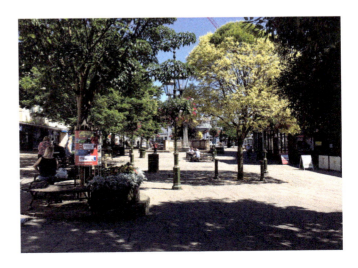

Horsham's Carfax.

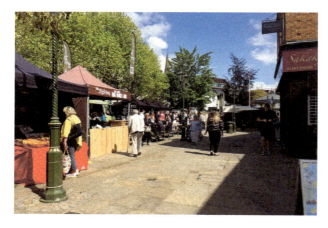

The Saturday market in the Carfax.

Benson's autumn fair.

As goods became more available in shops, the July fairs grew more focussed on entertainment, a pleasure fair with sideshows and lots of drinking. By the early nineteenth century the business of the fair was confined to just one day so the subsequent days were all for pleasure. According to contemporary reports, people flocked in from the surrounding countryside in their hundreds and thousands. The Carfax and all the central roads were filled with drinking booths, hand-winched roundabouts, shooting galleries, boxing and acrobatics, fat women and living skeletons, pickled salmon tents, whelk and fruit stalls, all doing a good trade. The traders camped around the Carfax in caravans and tents, much to the annoyance of local residents, who complained about insanitary conditions and rowdy behaviour.

Drinking booths were indicated by a small tree branch or bough fixed over the entrance. Some nearby houses cashed in on this tradition and put boughs above their doors to bring in customers, and were known as bough houses. Apparently, No. 30 Carfax was one such house that regularly took advantage of the custom, however it should be remembered that there has been renumbering of buildings in the 1800s and 1930s. Residents were by now becoming really fed up with the disruption. This exploded into a fight one Saturday in

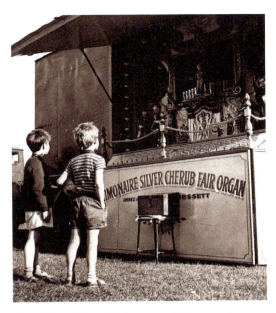

Above left: Silver gelatin print of Horsham fair, 1970s. (© Dorothy Bohm Archive)

Above right: No. 30 Carfax.

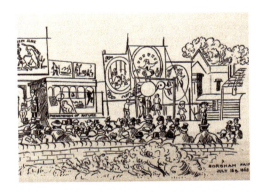

Drawing by Thomas Mann of Horsham July fair, 1868, reproduced from W. Albery, *A Millennium of Facts*. (© Horsham Museum & Art Gallery (Horsham District Council))

The gingerbread that Shelley so enjoyed for sale at Horsham Museum & Art Gallery.

July 1835, around midnight, involving about fifty men against the local constables. The Riot Act was read from the town hall and arrests were made. Eventually, the Home Secretary made an order in 1874 to limit the fair to just one day, then it was removed from the Carfax, to the Bishopric where it merged with existing markets. Finally, in 1886 it was abolished.

More Fairs and Wife Selling

Apart from the July fair, Horsham held four more fairs. Two were granted by charter in 1461 to the Archbishop of Canterbury and held on his land, known as the Bishopric. One of these was held on the Monday before Whit Sunday, so it moved with the Easter date, and the other was held on 27 November. Both were mainly for cattle and horses. Two other fairs had developed without charter, one on the 5 April for sheep and lambs and the other on 17 November, known as St Leonard's Fair. This was held in the forest, originally for feral horses, then for Welsh cattle. This was moved to the south-east of the common, and then, after the common was enclosed in 1813, to the Brighton Road, opposite the old Queens Head public house.

Henry Burstow, in his *Reminiscences of Horsham*, wrote about several instances of wife selling. In 1820 he tells of a woman called Mrs Smart with one child who was sold for 3s 6d to a man called Steere. They lived together in Billingshurst and she had another child, but sadly this relationship did not work out and she was sold again to a man called Greenfield. Both her first and second husbands complained of qualities that they could no longer endure, and thus another sale. At the November fair of 1825 a journeyman, or travelling blacksmith, exhibited his wife and three children for sale. The deal was done at £2 5s for the wife and one child, and although local people were concerned enough to contact a magistrate about the sale, nothing further was done. In 1844 the very last woman sold in Horsham was Ann Holland, also known as 'Pin Toe Nanny', for £1 10s. It seems she was sold to a man from Shipley called Johnson, who sold his watch to buy her. The 'marriage' lasted a year and they had one child, after which she ran away and later married a Jim Smith, with whom she apparently stayed for many years.

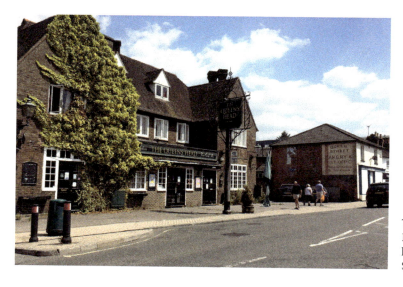

The old Queen's Head public house, Queen's Street, Horsham.

> **DID YOU KNOW?**
> The market area known as the Carfax has gone through at least eleven different spellings since the sixteenth century when it was known as Scarfolkes, which probably meant scarce of people, or an area of people who were poor squatters. By the late eighteenth century squatters were in legitimate houses and shops, and the area had been renamed Scarfax or Carfax, meaning four ways, which it isn't, unlike the one in Oxford, which is.

The very idea of wife selling is horrific to us today and has unsettling echoes of slavery. In the nineteenth century and earlier there were two types of wife sale. One very public in the marketplace with the woman delivered with a halter around her neck or waist, which was the 'ritual' type of sale. The other a more private agreement but with a contract signed by witnesses and usually conducted in a public house or bar. The 'ritual' sale was an invented tradition in the late seventeenth century, possibly as a response to war and the frequent breakdown of marriages. It was a quick and public method of obtaining a divorce and remarriage; thankfully part of the agreement was that the wife consented and often was already in a relationship with the purchaser. The increased reporting of wife sales in the early nineteenth century was also a reflection of the rising current of disapproval by evangelical, rationalist and radical or trade union sources, as well as the introduction of The Marriage Act in 1753 and 1823. This helped to stop the practice, although possibly also drove it into more secretive places. Thomas Hardy used the sale of a wife as the major theme of his novel *The Mayor of Casterbridge*, published in 1886 but set two generations earlier in the 1820s, and which explored the consequences of such an event when lightly undertaken.

Weekly and Monthly Markets

In addition to the five annual fairs there were the regular weekly markets, and Horsham had two such markets. The right to hold a corn market was granted by Henry VI in around 1460 and this was held on a Saturday. Another market seems to have been held on a Monday for poultry. Horsham was well known for breeding the Dorking five-clawed chicken and many of these were sent to the London markets. Considerable quantities of rabbit were also sent to London markets from St Leonard's Forest.

> **DID YOU KNOW?**
> In 1803 the poet Percy Bysshe Shelley, who was born nearby in Field Place, Warnham, asked his aunt to buy some gingerbread in Horsham market as he was going on a picnic. Horsham was well known for its gingerbread until the early twentieth century. Luckily, a recipe for this old-style gingerbread was found in Shelley's aunt's recipe book, so we can all enjoy it today. You can buy it at the museum or local food shop Crates in the Carfax.

In 1705 Queen Anne granted John Wicker of Park House a new monthly market to be held on the last Tuesday of every month for cattle and other goods. Perhaps unsurprisingly, given the number of markets, by mid-century this market fell into decline and although it was reinstated, it could not be sustained. There was considerable concern in the town about the possible demise of markets. Commerce was changing due to independent traders buying from the farm gate and selling direct to shops and residents, or even London, bypassing the local markets. So, a public meeting was convened to address the problem in October 1756, and an agreement was signed by eighty residents effectively agreeing to support the markets. A hundred years later in 1852 a new cattle market was established on alternate Wednesdays in the Bishopric, and the corn market continued on Saturdays at Swan Yard in West Street (now part of the Swan Walk shopping mall). Later a big new market hall was built in West Street with corn, poultry and cattle. The Corn Exchange was later bought for social events by The Black Horse Hotel and the market moved to the Bishopric until eventually it moved to the railway goods yard, where it stayed until it closed in 1966.

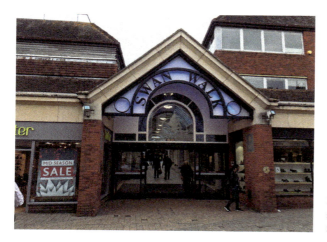

Entrance to the Swan Walk shopping mall in West Street, Horsham.

The Lynd Cross area at the crossroads of West Street, Worthing Road and Springfield Road, Horsham.

> **DID YOU KNOW?**
> The name of Lynd Cross marked the junction between the Bishopric or West Street and Springfield Road and was originally where a medieval market cross would have been, and subsequently the Shelley Fountain. The name means a cross made from lime wood and the name now only survives in the Lynd Cross public house near the site.

Welsh Cattle in Horsham?

It may seem surprising but there was a long tradition of Welsh cattle being driven to Horsham from the Welsh Marches. This trade may have originally been established due to the Lord of Bramber, William de Braose, being given estates in the Welsh Marches, as well as in Sussex, by King William after the conquest. The cattle were important as draught beasts for the iron industry in the Horsham area, as well as for beef at the November St Leonard's Fair, which provided meat in time for Christmas. The small Welsh black cattle are one of the oldest breeds in Britain, and date back to a time before the Roman occupation.

Evidence of the Welsh drovers in Horsham dates from a burial notice of 18 November 1609, of Roger Lewis, described as 'a Welchman, a drover of cattle'. Surprisingly, the reason for the death is not recorded. There are two more entries for Welshmen in the Parish Register, although they are not described as drovers; a John Williams and Hugh Bowen died in April and November 1586. The Welsh cattle trade clearly continued for centuries as William Cobbett, travelling though Wiltshire and Gloucester on his Rural Rides from 1821 to 1832, reported seeing 2,000 of the small black Welsh cattle in separate droves on their way to the fairs of Sussex.

It can be seen from this chapter about markets and fairs that Horsham has a strong and lengthy tradition of such events. It is good to know that it continues today, changing with the times but nevertheless a thriving combination of trade and pleasure, as in the past. At Easter there has been the Italian Festival, or Piazza Italia. Continuing on a gas-guzzling theme, and for the first time in September 2018, there was Ameri-car-na, a celebration of American cars, food and music, which has been hugely popular, as is Plum Jam celebrating VW cars. There is also the English Day of Dance and some new festivals such as the Caribbean and Spanish Fiesta.

In May there is an English market with local food, drink and classic British cars. In June and October there is a French market and craft fair, and in September a month-long festival of food known as the Big Nibble. Each week there are two markets, one on Saturday with food and drink such as bread, fruit and vegetables, sausages, game, gin, flowers and plants, and on Thursday the emphasis is on street food vendors. During December and the run up to Christmas the market is on both Saturday and Sunday also selling crafts, jewellery and other gifts. In addition, the nearby park is the venue for Benson's Funfairs, live music events and various festivals such as Enchanted Horsham and Funday Sunday.

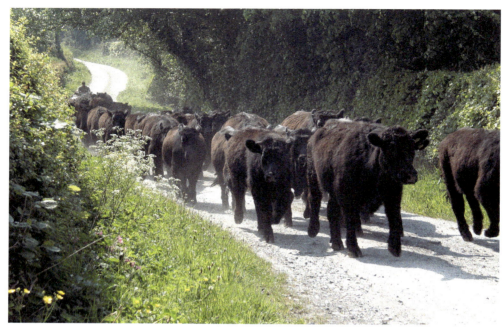
Driving of Welsh black cattle. (With thanks to the Welsh Black Cattle Society)

Italian cars in Market Square, part of the Easter Piazza Italia.

American cars in the park, part of the new Ameri-car-na Festival.

Circus Wonderland in the park in late summer.

The markets and fairs were, and still are, thriving, so what about the secrets of industry and trade? What was Horsham's wealth built on, and what is happening today? The next chapter looks to answer these questions.

3. Industry and Trade

Possibly the earliest industries in the Horsham area were the stone quarries, such as at Stammerham, near Christ's Hospital School. The name was Anglo-Saxon for 'settlement by a stone quarry or lake', which is a bit of a giveaway as to what was happening there. The first recorded evidence of industry in the Horsham area was the Roman brick and tile works at Itchingfield, around 2 miles south-west of Horsham. It is likely that the Romans also set up ironworks for arrowheads in St Leonard's Forest, an area rich in ironstone and charcoal. However, Horsham was a growing market town and other smaller industries and trades were developing to service the local people and markets. This continues today with new ventures in the brewing and viticulture trade.

Iron Industry

To make iron in the early Middle Ages you needed ironstone, charcoal and water. These Horsham had in abundance in St Leonard's Forest. In 1279 a family called Godelene de la Collegate, meaning 'dweller at the (char)coal gate', lived near the village of Colgate, which suggested that an early iron-smelting works was nearby. This was more than confirmed by a Lidar survey (aerial pulsed laser light) in 2011, which identified twenty-eight mine pits in the north of the forest near Colgate.

Iron ore was dug out of mine pits by digging a shaft of around 2 metres diameter from the surface into the iron-bearing rock, down to a depth of around 2 meters, and then widening it out along the seam of the ore. This must have been a dangerous business with the likelihood of dug out shafts collapsing. In fact, a Horsham parish burial record in July 1613 noted that a William Atkins, mine digger, was killed in a mine pit accident.

> **DID YOU KNOW?**
> In Sussex dialect, and of Anglo-Saxon origin, a house is said to be 'healed-in' when the roof tiles go on. Although it can refer to any roofing material, it commonly meant tiled by the use of Horsham stone.

Iron industry techniques developed from the lower temperature bloomery furnaces to the higher temperature blast furnaces thanks to the suitability of the St Leonard's Forest landscape. For example, water-powered bellows were needed for the new blast furnaces and the deep ghylls, or streams, of the forest could be dammed to create a pond, with the dam or 'bay' forming a roadway. Furnaces could then be built on the side of the valley

so that charcoal and iron ore could easily be loaded in the top of the chimney or flue via a platform. In addition to the mine pits in the north of the forest, two large profitable ironworks were developed in the south of the forest around the mid-sixteenth century by John Broadbridge. Upper Forge was on Hammer Pond and had a forge, while Lower Forge on Hawkins Pond, had both forge and furnace. The roadway at the head of both these ponds is called, not surprisingly, Hammerpond Road, and the long narrow ponds can be seen on the left as one travels south-east away from Horsham.

It is interesting that many French migrants were being recruited in the first half of the sixteenth century from the Pays de Bray, in north-eastern Normandy, south of Dieppe, where they had learned valuable ironworking skills, but where a lack of investment and the rising price of wood had closed the French furnaces. Migration reached its peak in the 1520s, and there is little doubt that this immigration helped to develop the skills needed to manufacture weapons, and a good export trade in guns and cannon had been established before the Spanish Armada in 1588. After this the government had more control of the trade. There were much greater later migrations of protestant Huguenots into Britain after 1685 following their persecution in Europe.

A burial notification confirms the presence of the migrants. In January 1556 the burial took place of 'Peter, the Frenchman, a collier, cruelly murdered in the Forest of St Leonard.' We do not know the reason for, or how, he died but fear and jealousy of the migrant, the stranger, is still with us.

Hawkins Pond on Hammerpond Road, Horsham.

Both the Upper and Lower Forge were out of use by 1664 and derelict two years later. What had happened? It was a question of scarce resources as powerful ironmasters competed with each other. The ownership of the forest had passed from the Duke of Norfolk to the Crown, and the Crown saw it as a good source of income, issuing warrants for the timber willy-nilly and subletting the iron furnaces. Grievances between the ironmasters who held these subleases escalated over rights and resources. Fighting broke out among their retainers, and it was reported that twenty or more of John Caryll's men, 'the most dissolute, disordered, quarrelsome and riotous persons set upon Gratwick's men with swords, daggers, staves and other weapons, wounding and beating them'. In another incident, a leading Caryll man went to the mine pits, struck a Gratwick man with a mattock, threw him in the pit and threatened to stone him, unconcerned as to whether he would kill him. These disputes carried into Horsham town with knives drawn and victims chased.

DID YOU KNOW?
Boldings Brook, which runs to the east of the A24 south through Warnham Nature Reserve and on south to join the Arun, was locally called the Red River due to the discolouration of its water by the iron-rich clay and later by Warnham brickworks in the nineteenth century.

However, the final end of the iron industry in Sussex came as greater profits could be found in the Midlands with the discovery of coal and new iron deposits. The Civil War completely finished off Upper and Lower Forge as the Parliamentarian soldiers made sure they were trashed and unable to make weapons for the Royalists.

Stone Quarries

The Horsham area was, and still is, well known for the production of large grey flat Horsham stone, a calcium-rich sandstone which could be split and used in roof tiling, paths and gravestones. It was quarried and valued as far back as Roman times and has been found in use at Bignor Roman Villa and in paving on Stane Street, now the A29.

The main outcrop was a low ridge that ran from Monks Gate to the south of Horsham, through Nuthurst and west towards Sedgwick and Denne Hill. The area around Sedgwick was particularly rich in Horsham stone as evident in the buildings and gardens of Sedgwick Place, while the Denne estate had numerous productive quarries. These provided a useful annual income for the Eversfield family in the seventeenth century. The Michell family also grew rich from their quarries at Stammerham, now the Christ's Hospital School site to the west of Denne.

The stone was dug from shallow pits less than 3 metres deep. This was not that difficult, however the stone was very heavy, transport was a challenge, and the stone tiles needed good timber oak beams to support its weight in roofing. Trading in the stone is recorded as far back as the fourteenth century when Horsham roof tiles were bought

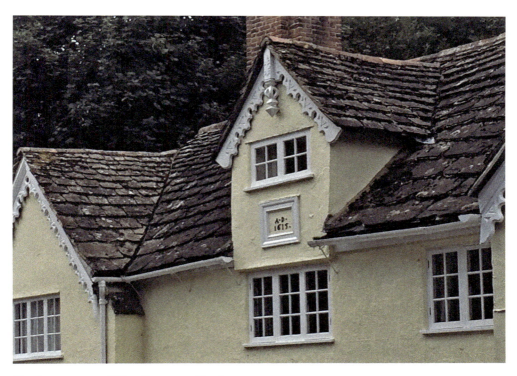

Horsham stone roof tiles, Causeway, Horsham.

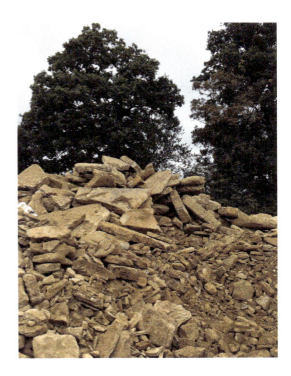

Quarried Horsham stone. (With kind permission of Horsham Stone & Reclamation Ltd, Lower Broadbridge Farm, Horsham)

for a barn near Chichester. Demand continued until the early twentieth century when it began to reduce and quarries were closed. However, in the 1930s a local stone quarry by Broadbridge Heath started production again, and Horsham Stone and Reclamation Ltd now annually digs Horsham stone from the quarry on site.

Brick Making

Horsham is on the edge of the High Weald, which means it is sitting on sand and clay, ideal material for tile and brick making. Also, because of the iron oxide in the clay the bricks are of a good red colour. Of course, it was the Romans who first introduced brick and tile making to Sussex, more locally at Itchingfield and Wiston. However, the Horsham area was rich in timber for building, so bricks did not really take off as a building material until the early eighteenth century.

Until then bricks were useful to line the blast furnace kilns of the iron industry, as they could withstand high temperatures. It is recorded that bricks were made in St Leonard's Forest in 1584 for the Gosden furnace and for the house of the ironmaster Gratwick at Cowfold. It was the wealth and status of these ironmasters that encouraged the use of bricks as they used them rather than wood to build their mansions.

Around this time brick makers were establishing themselves on Horsham Common. It is recorded that Nicholas Dinnage ran a brick kiln in 1665, and a century later there were five brick kilns in operation in Horsham. Often these new entrepreneurs combined brick making with other trades, such as pottery, farming or lime burning and even brewing. One such was Henry Michell, who bought a pub with land in Three Bridges near Crawley and used the land for brick making. In the nineteenth century the trend was for builders, naturally enough, to own their own brickyards. In the 1880s, a man called Mill, a Horsham builder, went into partnership with Smith, a brick maker from Worthing, and they established a brickyard near the railway at Southwater using the new rail to transport the bricks.

The late nineteenth century saw a boom in housebuilding and an increasing demand for bricks. With this came a drive to mechanise and speed up the process. The Lintott family of Horsham Engineering Works were at the forefront with their belt-driven pugmill, which mixed clay to the right consistency for moulding. They continued in production until the 1950s. In the early twentieth century there were seventeen identified brickworks sites in Horsham, including three in Southwater. However, the drive to mechanisation needed large investment, and many of the smaller family-run brickyards were forced to merge or were taken over by larger companies.

DID YOU KNOW?
The Sussex and Dorking United Brick Company used the image of an iguanodon, fossils of which were unearthed at its brickyards, for its logo. It carried this further by building in brick a cocktail bar at London's Olympia in the shape of an iguanodon.

Warnham Brickworks, Langhurstwood Road, Horsham, now Wienerberger UK.

The logo of the Sussex and Dorking United Brick Company was the iguanodon, of which fossil bones were found on their site. The company regarded it as a symbol of strength and agelessness. They took over Redland Bricks and retained the name, until they themselves were taken over by the Ambion Brick Company, then by the multi-national Austrian company Wienerburger Ltd. Their Southwater brickyard closed in 1982, leaving the Warnham works the largest in the south-east, and the last operating brickworks in Horsham situated on Langhurstwood Road, off the A264. Recently, rationalisation of the whole site means part of it is threatened to be turned into a waste incineration site.

Mills
It was mentioned in chapter two that Horsham's corn markets were important and that a new, rather grand, corn exchange was opened in West Street in 1866. Grain needed to be milled and so there was an equally long history of milling, using water power more than wind, although both were used, and there were even steam mills. The earliest recorded mill was on the River Arun behind St Mary's Church, although the exact position is not known.

Champion Mill was a new windmill built in the 1820s on what was recently enclosed common land in Roffey. Further along the Crawley Road was another new smock windmill, the Star Mill. It was the last to be built in Horsham and had rather a tragic history. In 1873 a small boy of barely two years old, George Lane, walked into the windmill

sails and was killed. Then Thomas Clifford, the next miller, aged forty-six, hung himself from a beam in the mill. A year later in 1882 two brothers from Kent, Edward and Walter Weston, took over the tenancy of the mill. Six years later one of the millstones that was being dressed at the time fell on Edward's leg, crushing it. He died from his injury aged thirty-eight. The remaining Weston brother, Walter, vacated the Star Windmill and it was pulled down in 1895 as it was becoming unstable. Walter then took over the Star Steam Mill, which ground peas, maize and oatmeal. Milling appears to have been full of dangers, as another small boy named Streater, aged around five years old, got into Wimblehurst Mill, near the Dog & Bacon public house, where his father was the miller. He became entangled in the machinery and was killed. It is thought that another miller, Mr Dale, was crushed to death when this same windmill blew down and was destroyed.

Most wind mills were built of wood and few have survived, although there are six still in the area. There is the Town Mill, Warnham Mill and Ifield Mill, all water driven, and two windmills. King's Mill at Shipley, a beautifully restored smock mill, was built in 1879 and owned by the writer Hilaire Belloc from 1906 until his death in 1953. The second windmill was at Lowfield Heath, which was later moved to Charlwood. Finally, the steam-powered mill owned by Prewett's, on the Worthing Road near Sainsbury's, has gone through a number of reincarnations and is now upmarket flats, but the old building and name has been retained.

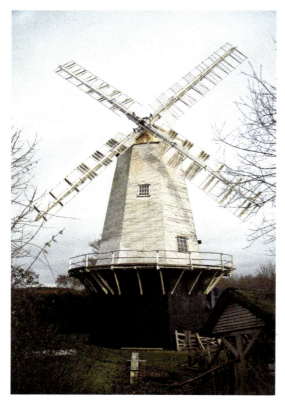

Shipley Mill. (With kind permission of Alex Newton, www.tallguypictures.com)

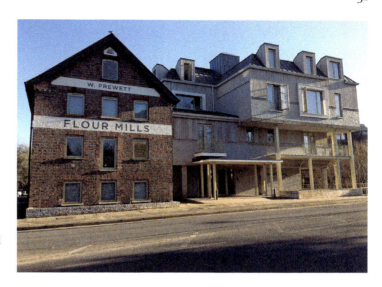

The recently redeveloped Prewett's Mill, Worthing Road, Horsham.

Brewing, Tanning and Trade

Many residents of Horsham will remember the King and Barnes brewery on Albion Way, which closed in 2000 and is now the site of flats, built to retain the original brewery building profile. As in most market towns brewing was an important business. In the sixteenth century there were at least five breweries in the town. It was down to three by the nineteenth century. King and Son in the Bishopric, Barnes in East Street and Michell on the Worthing Road. Henry Michell, whom we have come across in the brick-making business, was a successful Victorian entrepreneur. Although probably set up in the brewing business up by his father, Henry Michell expanded not only into brick making, but also gas and water works. However, it was brewing that made his fortune.

It's a familiar story that the breweries gradually amalgamated, leaving King and Barnes as the most successful for a century. What is less familiar is the recent rise of independent craft beers. From the skilled brewers made redundant from King and Barnes have blossomed Hepworth & Co. Brewers Ltd opened in 2000 at Pulborough, and the Firebird Brewery Company (a phoenix from the ashes) opened in 2013 by two master brewers, Bill and Richard, on the old brickworks in Rudgwick. A year later the Greyhound Brewery opened in West Chiltington, brewing traditional cask and craft ales.

In the centre of Horsham on an industrial site is Weltons Artisan Brewery, founded in 1995 by Ray Welton, a drinks distributor, and set up in Horsham in 2003 making a wide range of cask ales including Horsham Old and Horsham Pale Ale. Another microbrewery is the Kissingate Brewery in Lower Beeding, which developed from a hobby by its owners. They specialise in brewing old-style porters, stouts and milds and are the recipient of many awards. Newer still is the microbrewery Chapeau Brewery in central Horsham, which is run by two cycling and beer enthusiasts, and in Wisborough Green is Brolly Brewing making small batch craft beer on a farm. The Dark Star Brewing Company at Partridge Green, bought by Fuller's in 2018, reopened the old Anchor Tap pub in East Street, Horsham, and then sold it to the Pale Moon pub company. Another

Kings Gate apartments on the original King & Barnes site, Albion Way, Horsham.

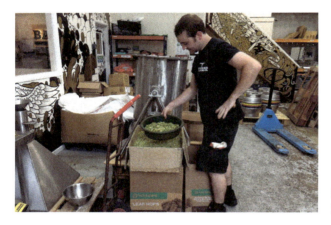

Paul carefully sieving hops at Firebird Brewery.

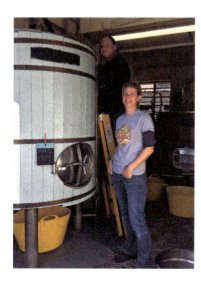

Sarah Allen, owner with husband Nick Allen of the lovely Greyhound Brewery, West Chiltington, and brewing tank.

old pub site, the Horse & Groom, which was briefly the restaurant Wabi in East Street, reopened in 2018 as Brewhouse and Kitchen. It brews seven different beers on site, sells over fifty draft and bottled beers and provides brewing experience days for the enthusiastic hobbyist.

A number of these local craft beers are available at the Kings Arms in Bishopric. Newly renovated in 2018, it dates from 1667 and it is likely from pottery fragments found there that it was a drinking place from medieval times, when it would have been at the heart of the Monday market in the Bishopric.

Continuing on an alcohol theme, and just as entrepreneurial and exciting, are the new developments of vineyards at Coolhurst and Mannings Heath. Coolhurst vineyards have 6.5 ha of vine producing a Pinot Noir sparking rosé, which has already won awards, and a Blanc de Blanc. Mannings Heath Golf and Wine Estate is owned by a family of experienced South African viticulturists, who have 16 ha of vine at Leonardslee and at Mannings Heath. With the trend for craft gin taking off, Horsham has not been behind. A new gin called Cabin Pressure is a vacuum distillation of gin flavoured with organic juniper, coriander and other botanicals, from a small company based in St Leonard's Road, Horsham. A local shop in the Carfax called Crates is foremost in promoting local food and drink and even has a very popular gin club.

The twentieth century saw two big white-collar employers set up in Horsham. In 1937 the Swiss pharmaceutical company CIBA arrived and built a factory at Parsonage Road. A new research laboratory opened in 1965, employees increased to 750, and it amalgamated in 1966 with Sandoz, then in 1970 with Geigy, to become Novartis. Following further acquisitions and rationalisation Novartis closed its Horsham site in 2014 with a loss of around 400 jobs. A northern branch of the University of Brighton or an innovative science park were both suggested for the now empty site, but the likelihood is that it will be used for more housing.

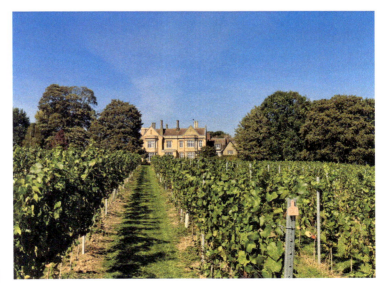

Coolhurst Vineyard. (With kind permission of Charlie and Will Scrace Dickins, www.coolhurstvineyards.com)

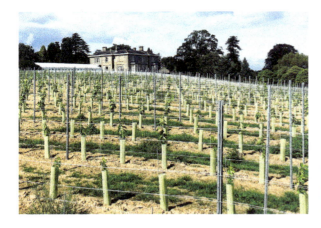

Leonardslee Vineyard. (With kind permission of Patrick Rea, PR for Leonardslee Lakes and Gardens, www.leonardsleegardens.co.uk)

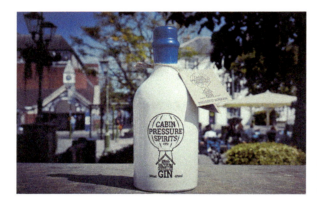

Bottle of Cabin Pressure gin. (With kind permission from David Howard, www.cabinpressurespirits.com)

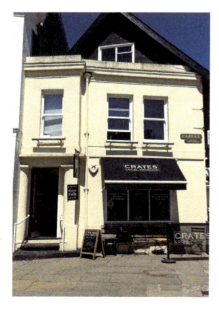

No. 24a Carfax, Crates Local Produce Shop. (www.crateslocal.co.uk)

The insurance company Sun Alliance arrived in Horsham in 1964 and made quite an impact on the town. It amalgamated with Royal Insurance Company in 1997 to create Royal Sun Alliance. At its height it had more than 2,000 employees and also impacted the shape of Horsham town centre with its development of Chart Way and large office blocks. Since then it has also downsized its business and its buildings, among others actions selling Parkside to West Sussex County Council.

Something that is not widely known is that Horsham has been the dimmer switch capital of the UK since 1972. Doyle and Tratt Products Ltd make and sell these, as well as sockets, under the brand name of Varilight. Another first for Horsham was the establishment in 1987 of the oldest and largest UK game developers, Creative Assembly, which wins awards for the impressive quality and detail of its computer games.

With regards to trade there has been just as much change. In November 1784, Thomas Medwin, a lawyer with a considerable private practice in Horsham, prepared a draft list of all the tradesmen in the town. This was on the request of William Bailey for his first nationwide trade directory. Medwin concluded his list of nineteen trades by writing that 'Horsham is a prime market in Sussex for grain and poultry. The only manufacturing here are leather, hats, sacks and brooms.' Indeed, his list names two tanners, a currier, one sack manufacturer and one hat manufacturer. There were also drapers, grocers, mercers, cutlers, builders, maltsters, three lawyers and two surgeons, one highly skilled watchmaker and a timber merchant – all the trades one would expect in a rural market town in the eighteenth century to service the local population and trade further afield. There were good links with London via newspapers and stagecoach routes, with coaching inns like the Anchor and the King's Head to service them. Perhaps surprisingly, Sarah Hurst, eldest daughter of Richard Hurst, a Horsham tailor in whose drapers shop she worked, travelled regularly up to London to buy textiles for the shop and to catch the latest plays.

Parkside, North Street, West Sussex County Council and Horsham District Council offices.

The leather industry had been in the town since the fifteenth century, probably earlier, due to the availability of cattle and clean water. Originally the town tanneries were to the west, at Tan Bridge, hence the name, and some remained here while others moved to the common, north-east of the town. Tanning was a smelly business and the common was away from the main population. However, by the nineteenth century the tanneries were closing. First to go was the lower tanyard to the south of the Brighton Road; the upper on the north side lasted until 1911 – at which point there were still thirty-three people employed in the industry – and it was sold to a tannery business from Bermondsey. There were plans to reopen with a more modern leather business, so the tanyard was being refurbished by the new owners with new machinery. However, a devastating fire in August 1912 closed it for good.

With leather being produced locally, saddlery was also a local product. Victorian and Edwardian society was still horse-drawn and so the demand for saddles, harnesses, collars and whips still continued. The trade was only harmed by the bicycle at the end of the nineteenth century, and the motor car in the early twentieth. Horsham's much respected saddler, William Albery, was in at the end of this long tradition. Albery was a writer, amateur local historian, calligraphy expert, musician and leader of Horsham's Silver Band, collector of saddlery, and, of course, a skilled saddler himself. Times necessitated that he diversified from saddles to other leather goods such as belts, dog collars, leads, straps, brushes, cases and luggage, which was how he continued to provide a good trade from his shop. His collection of saddlery memorabilia now resides in Horsham Museum.

From all this talk of industry and commerce we turn to more rural affairs in the next chapter and consider Horsham's local forest, St Leonard's Forest, and the common that used to wrap around the north and east of the town until enclosure gobbled it up in 1812/13.

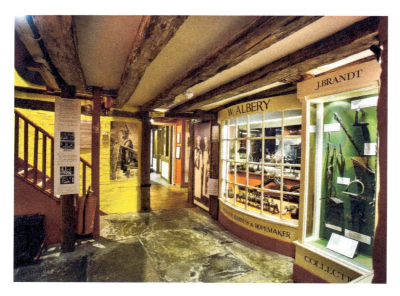

Museum display of William Albery's saddlery and leather goods. (© Horsham Museum & Art Gallery (Horsham District Council))

4. Forest and Commons

Horsham is indeed lucky to have a forest on its doorstep. It is now a popular place for dog walkers, ramblers and horse riders, but it was not always so and at the turn of the twentieth century Horsham residents and the local authority fought hard to keep the forest footpaths open – but more of that later. Readers will be surprised that the dragon is not featured in this chapter on the forest, but don't worry, it appears in the next chapter on Myths and Legends – can't forget the Horsham dragon! The common wrapped around Horsham to the north and east and butted up against the forest. Enclosed in 1812/13, the common has now virtually disappeared under housing, although a small corner is left by the Dog & Bacon pubic house on North Parade.

Where is the Forest?

St Leonard's Forest lies to the east of Horsham and south-west of Crawley, almost merging with Tilgate Forest, south of Crawley. There are two main villages that lie within the forest: Colgate in the north on Forest Road, and Lower Beeding to the south of Plummers Plain on Sandygate Lane. Today much of the forest is in varied private ownership such as private estates, schools, farms, gardens and golf clubs, and so is closed to general public access. However, a portion is retained by three public bodies. West Sussex County Council in the north owns Buchan Country Park, and to the south Horsham District Council owns areas identified as Leechpool, Owlbeech, Severals Bottom and Forest Walk, all of which are managed by their Countryside Services Unit.

Remains of the common, North Parade.

The middle section of the forest, which includes Sheepwash Gill, Mick's Cross and the Lily Beds – a total area amounting to 289 ha – is owned by the Forestry Commission and is under the management of Natural England. All these areas are still open to the public with good access through car parks, footpaths and rights of way. Two long-distance walking trails cut through the forest: the High Weald Landscape Trail runs east beginning at Horsham station for 94 miles to Rye, and the Sussex Ouse Valley Way begins just south of Lower Beeding and runs 42 miles to Seaford Bay on the coast.

Unlike forests such as Ashdown in East Sussex, the boundaries of St Leonard's Forest are difficult to define without a recognised pale, or ditch and fence, and of course the total extent has reduced over time. However, an approximation can be made through archival evidence of the original size and position of the forest, which was a remnant perhaps of the ancient pre-Saxon forest wilderness known as Andredeswald.

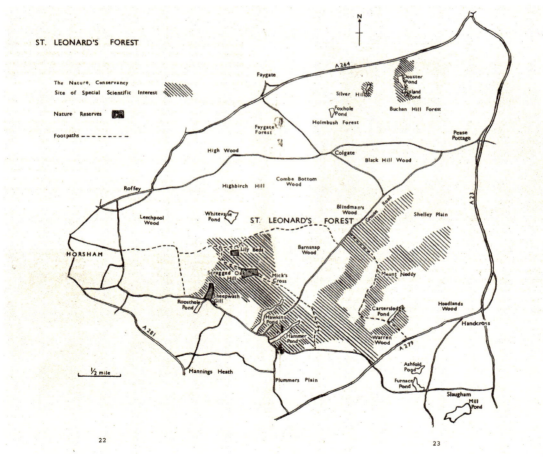

Sketch map of St Leonard's Forest in *Natural History of St Leonard's Forest*, 1983. (© Horsham Natural History Society)

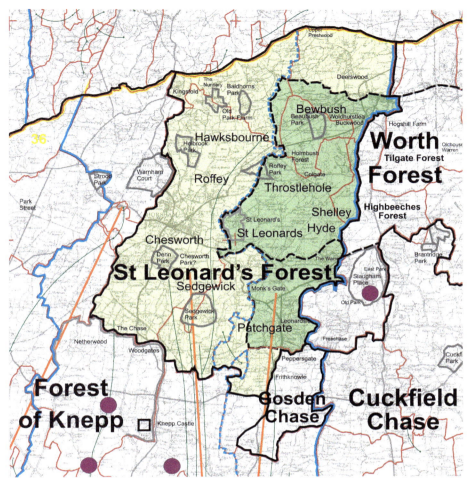

Map of the likely historical extent of St Leonard's Forest in green, core of forest in dark green. (With kind permission from Dr Graham Jones and Dr John Langton of Oxford University, www.sjc.ox.ac.uk)

Who Owned the Forest?

First one should make clear the difference between a forest and a woodland. A forest is a legal entity owned by the Crown for preserving the hunting of animals, and a woodland is just trees. Thus, control of a forest and its surrounds passed from Saxon kings to Norman kings after the Conquest. The whole region of the Bramber rape, including Horsham in the manor of Beeding, was gifted by William I to his Norman supporter, William de Braose. The forest was thus never a royal forest but a park. Other forests surrounded Horsham, like Bewbush, Knepp, Chesworth and Sedgwick with moated houses and castles for hunting parties, and it is thought that Edward I and II hunted these forests. William de Braose settled in and built his castle at Bramber. He founded Sele Priory at Bramber as part of the Benedictine Monastery at Saumur in France and gave them the resources of St Leonard's Forest, the rights to graze, take horses, timber and taxes.

For political purposes Richard II severed all ties between English and foreign religious institutions and so Sele Priory gradually lost influence, monks and money. A descendant of the de Braose family, the 1st Duke of Norfolk, John Howard, then gave the forest rights to the newly founded Oxford Magdalen College in the mid-fifteenth century, and it stayed under the college's control until the nineteenth century.

> **DID YOU KNOW?**
> St Leonard's Forest takes its name from a chapel, originally in the centre of the forest and now thought to have been near the hammer ponds on Hammerpond Road. The chapel was dedicated to the French hermit St Leonard, a favourite with the medieval Benedictine order. He was the patron saint of prisoners, and stories abound of him releasing prisoners from chains and helping them live a good, useful life. He established an abbey at Noblac, which became a stopping point on the pilgrimage route to Santiago de Compostela.

Control of the forest went to and from the Dukes of Norfolk, as they fell in and out of favour with the Crown, until it was given to Thomas Seymour, Baron Seymour of Sudeley and Lord High Admiral, of Wolf Hall in Wiltshire. This was a man whose ambitions rose with those of his family. One of his four sisters was Jane Seymour, Henry VIII's third wife. Although a prosperous landowner and aristocrat, Thomas Seymour had further ambitions; he married Henry VIII's widow, Katherine Parr, and schemed to kidnap the young king, with his stepsisters Mary and Elizabeth. There were suggestions that he also behaved inappropriately to the young princess Elizabeth, hoping to procure marriage with her after Katherine's death in childbirth. However, his plotting and schemes were uncovered, and he was arrested, examined and executed for treason on 20 March 1549. It was reported that on hearing this news Elizabeth said 'This day died a man with much wit, and very little judgement.'

It appears that Seymour owed Magdalen College tithes, or taxes, and in a letter to the college he suggested he would build a new town in the forest to provide opportunities for increased taxation – perhaps a premonition of Crawley new town? The size and the location of this proposal remains a mystery but it seems he changed his mind and went for small farms and cottages instead. After more Tudor executions the forest came fully into Crown possession and so control became even more complicated, with subletting and disputes.

It is clear, however, from various surveys in the following centuries that St Leonard's Forest was losing its good timber through mismanagement and over felling so that it was becoming a devalued woodland of secondary growth and heathland. By the eighteenth century the forest was in the ownership of Sir Richard Weston, who tried to improve the soil for arable farming without much success, using various techniques he had learnt in the Netherlands. The subsequent owner, Sir Edward Greaves, thought rabbits would be successful on the poor land, and so it proved to be.

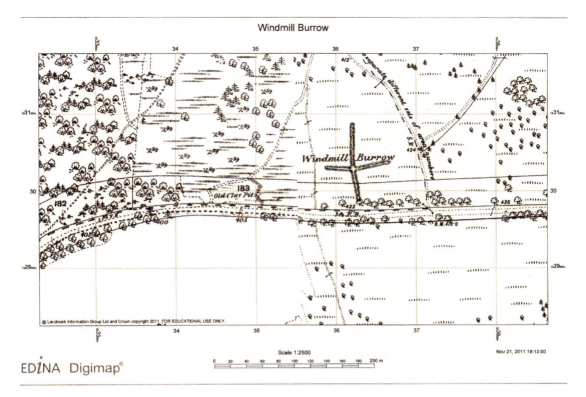

Windmill Burrow, Colgate. (With kind permission of EDINA Digimap and Landmark Information Group. © Crown Copyright and Landmark Information Group Limited 2019. All rights reserved 1875)

The Great Warren in the centre of the forest can be identified by the remains of boundary and pillow mounds. These latter were mounds of soft earth into which the rabbits could burrow to keep them dry, safe and easily harvested with nets. These pillow mounds had regional variations, the ones in Sussex being very long – over 50 metres in length – and often joined, as in the windmill burrow. This can be seen on an old 1875 map, near Colgate and by the side of Forest Road, looking like a windmill with four radiating mounds from the centre.

Eventually the rabbit business was overtaken by the easy availability of wild rabbits. With the establishment of the railways came easier transport, and a better appreciation of the English landscape as picturesque. The forest landscape was now regarded as valuable property, just right for a large house and parkland within easy distance of London. The descendants of Sir Edward Greaves, the Aldridge family, held New Lodge, also known as St Leonard's, and the central section of the forest. Coolhurst to the south of them has been in the same family since 1830, the Scrase-Dickins. Holmbush to the north was sold by Lord Erskine in 1825 to Thomas Broadwood, a very successful piano manufacturer, who had sent a gift of one of his pianos to Beethoven.

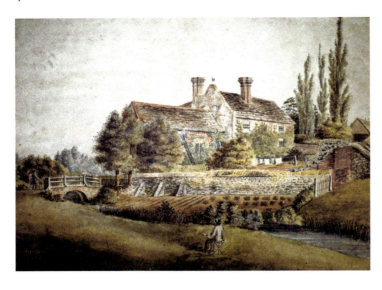

Painting by unknown artist of Chesworth House. (© Horsham Museum & Art Gallery (Horsham District Council)

DID YOU KNOW?
John Howard, 1st Duke of Norfolk and great supporter of Richard III, was killed just prior to the death of his king at the Battle of Bosworth Field in 1485. It was an arrow in the face that got him. He was the great-grandfather of two queens of England: Anne Boleyn, second wife of Henry VIII, and Catherine Howard, fifth wife of Henry VIII. Catherine spent her young life at Chesworth House in Horsham under the rather lax supervision of her step-grandmother, Agnes Howard, Dowager Duchess of the 2nd Duke of Norfolk. It was some of the liaisons she made here that sealed her death warrant, including the unwanted attentions of her music teacher when she was a very young teenager.

In 1803 John Aldridge sold 1,000 acres of the southern part of his forest estate to Charles Beauclerk, who built a house called St Leonard's Lodge and planned out the parkland gardens. This family were supportive of Mary Shelley, author of *Frankenstein* and widow of Percy Bysshe Shelley, after she returned to England. Mary was keen on Charles's eldest son, Aubrey, whose first wife, Ida Goring, died by falling into the Leonardslee hammer pond aged twenty-four. The inquest found she had probably been 'seized with giddiness'. Aubrey sold the estate after his father's death and it was bought in around 1852 by William Hubbard, a wealthy merchant trading in Russia, who married into the Loder family. He rebuilt the house and renamed the estate Leonardslee. Sir Edmund Loder had an interest in new plants and the science of horticulture, creating a beautiful garden. This was sold by the Loder family in 2010 and was closed to the public. However, it was bought in 2017 by Penny Streeter of Mannings Heath Golf and Wine Estate, whose team have restored the garden and it is now open again to the public.

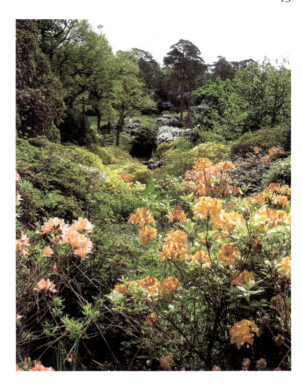

Leonardslee Gardens, May 2009.

At the turn of the twentieth century the new owner of the Aldridge estate in the centre of the forest, Edmund Molyneux, a rather shadowy figure, started erecting barriers and notices of private property across well-used footpaths in the forest. Horsham residents were not impressed and there were numerous outraged letters in the local press. The local authority took up the cause and held an inquiry as to the precedent for twelve rights of way through the forest. The local branch of the Commons and Footpath Preservation Society weighed in and mass rambles using the footpaths were organised. Molyneux took it as far as the High Court but eventually conceded three long footpaths, two north–south and one central east–west through the forest. Unsurprisingly, Molyneux did not stay long in Horsham as he was deeply unpopular. Even today, woe betide anyone who tries to privatise public footpaths or forests!

DID YOU KNOW?
The old rhyming song says of the forest 'Here the Adders never sting, nor the Nightingales sing'. Sadly, these days there are far fewer adders in the forest than there was when this story came about. However, in the late twentieth century the Forestry Commission warden had a spaniel dog of whom it was said he was bitten so many times by adders that he was immune to the sting.

An indication of the current appreciation of St Leonard's Forest was made clear when Leechpool and Owlbeech Woods were chosen by *Guardian* writers from a whole world of wonderful destinations as one of the best travel discoveries of 2017. The woods were described as a hidden gem. Journalist Andy Pietrasik wrote alliteratively of time travelling while tramping through the tunnel of trees, and a sense of seclusion amid the forest paths knotted with ancient oak roots. These two woodlands are a part of St Leonard's Forest, which is easily accessible from Harwood Road and has a car park. They are maintained by Horsham District Council with the help of volunteers from Green Gym. The 55 acres of Owlbeech are being restored to heathland with all the ecological diversity that will bring, while Leechpool's 30 acres are well wooded with deep ghylls and shallow streams.

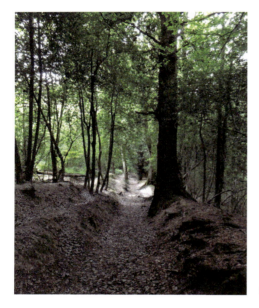

St Leonard's Forest footpath.

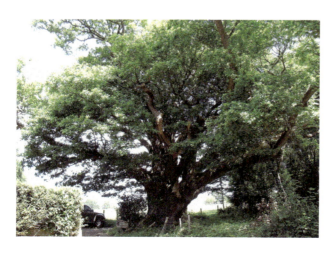

The Sun Oak, Hammerpond Road.

Where Was the Common?

The common was a large area of common ground running around the town of Horsham in a crescent shape from the north to the east, meeting the forest on the east. The acreage at the beginning of the nineteenth century was estimated to be 689 acres, with 58 acres encroached upon.

Legal rights over the common were deeply rooted in the feudal manorial and burgage tenure system. The ownership of the actual land, a freehold of the common, lay with the lord of the manor, in this case the Duke of Norfolk, while the right to gather resources and graze animals lay with the burgesses. The burgesses were the original fifty-two property owners, people who incorporated the borough and who owned, freehold, their properties in the town. Although neither the duke nor the burgesses could give freehold title to others to enclose areas of the common, they could, and did, give leases for small enclosures, provided both were consulted and agreed. It is estimated that in the late eighteenth century fifty people had been granted leases with eleven extra parcels of land, with the suspicion that the duke had not always consulted the burgesses before issuing leases.

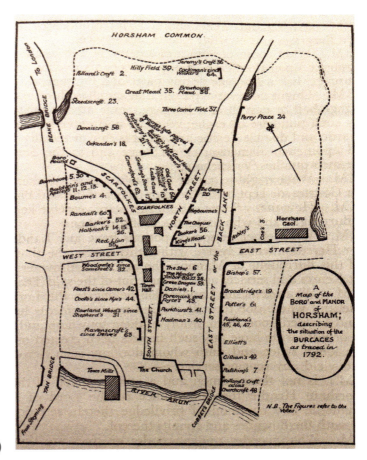

Map of Horsham town centre, including Burgages, dated 1792, reproduced from Albery's *A Millenium of Facts*, 1947. (© Horsham Museum & Art Gallery (Horsham District Council))

The public had always had free access over the common, and there was no crime of trespass in travelling over the common. As noted, town events such as the St Leonard's Fair were held on the common after moving from the forest itself. Sports such as bowling and cricket were held on the common, and as the Napoleonic Wars threatened, volunteer soldiers drilled and camped on the common, while condemned prisoners were taken from the County Gaol and hanged there to the entertainment of all.

Before it was enclosed, the common was a particularly useful area into which Horsham town could place its dirtier and smellier manufacturing, away from the growing population in the town. Although there were fears of robbery at night, the height and openness of the heath was ideal for windmills, and a healthy, safe place for an isolation house. The common also offered opportunities to a bold and determined individual to enclose a bit of land on which to build a house and establish a smallholding or business, albeit on an agreed lease. St Leonard's Forest in contrast was largely in the hands of individual landowners, and encroachments were unlikely.

> **DID YOU KNOW?**
> Leechpool wood gets its name, perhaps unsurprisingly, from leeches. These little bloodsuckers were regarded as useful by doctors who used them for blood-letting. It is said that in the late eighteenth century a Dame Railey used to collect these leeches from a pond in the forest called Middle Park Pond and sell them to local doctors and chemists.

An 1831 map shows four windmills. Champion's Windmill had been granted leases on the common from 1765 when it was stated that it had recently been erected by John Champion on half an acre. Near to Champion's Windmill was Dr Lindfield's inoculation house where in 1774 John Baker, a solicitor living at Horsham Park House, had his servants inoculated against smallpox and they spent three weeks in isolation, with him bringing them warm punch and jelly to cheer them up. He was an unusual and kind employer, for although Horsham suffered from recurrent outbreaks of smallpox, the townspeople were very resistant to the idea of inoculation.

The common was enclosed in 1812/13, and split up for farms and plots. The main beneficiary was a local wealthy landowner, Robert Henry Hurst, who was able to purchase parcels of land from the Duke of Norfolk. Although often portrayed as a tragic theft from the people of Horsham, in reality it was the logical way for Horsham to spread, develop and accommodate its burgeoning population of around 3,000 at this time. Park House and 18 acres of garden were sold to the local council in 1928, the house for offices, a reference library, reading rooms and a museum. The gardens provided a very central public park with tennis, swimming and other sports, which has so far been enjoyed by generations of Horsham residents, which is perhaps some consolation for the loss of the common.

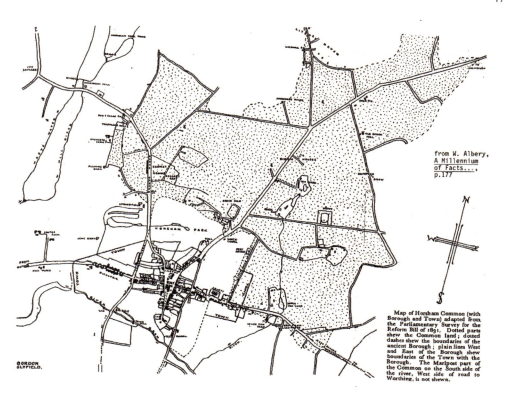

Above: Map of Horsham Common reproduced from W. Albery's *A Millenium of Facts*, 1947. (© Horsham Museum & Art Gallery (Horsham District Council))

Right: Horsham Park in autumn.

In the next chapter we look at myths and legends, most of which are related to the forest, which is perhaps unsurprising given the terrific legend of the Horsham dragon, and who doesn't love stories of dragons?

5. Myths and Legends

Dragons

At the beginning of the seventeenth century there was a story that came out of St Leonard's Forest that illustrates early medieval fears of wild and dangerous forests. In 1614 a pamphlet was published in London that described a serpent, or dragon, living in the forest 'in a vast and unfrequented place, heathie, vaultie, full of unwholesome shades, and over-growne hollowes'. The serpent was reported to have a territory of 3 or 4 miles and often had been seen near Faygate, to the north of the forest, and only within half a mile of Horsham itself.

There was a very detailed description of the beast attributed to John Steel, Christopher Holder and a widow woman living near Faygate. The serpent or dragon was said to be 9 feet or more in length, as thick as a cart axle, thicker in the middle, and to leave a noxious slimy trail. It had a white circle of scales around its neck, black scales along its back and was red underneath. It could raise its head and neck and look about attentively, it had large feet, and more worryingly, two big bunches on either side of its body that, it was supposed, would develop into wings. It spat venom around 20 metres and by doing so had killed a man, a woman and two large dogs. It had not eaten these bodies as it was thought it fed on a nearby rabbit warren, which had been found to be quite depleted. There has been mention of a later pamphlet that recounted the killing of the dragon, but this pamphlet no longer survives, and rather spoils a good story.

There have been numerous theories about what the dragon was and where it came from. In the mid-nineteenth century it was suggested that superstition and imagination

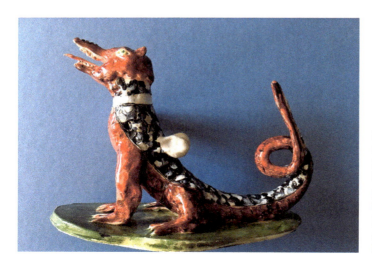

Model of Horsham dragon by sculptor Jean Holder, based on an illustration in a 1614 pamphlet and on display in Horsham Museum. (© Horsham Museum & Art Gallery (Horsham District Council))

could have converted a misshapen log into a serpent, and the disappearance of rabbits could be attributed to poachers. Another suggestion was that it was a satire of a petty tyrant, unnamed, of the district. It could of course have been a hoax, and many thought it was encouraged, if not instigated, by smugglers and gamekeepers to keep people away from the forest. However, local historian Sue Djabri has pointed out that smuggling activity was not prevalent in the forest until a much later date. In researching the likely truth of the story, she examined the Horsham Parish Register for the period to identify the names of the people involved, and found some likely candidates. She also suggested that the rabbit warren in question could have been that situated on the Bewbush estate, north-east of Colgate, the Sibball's Field Warren. There is certainly an unnerving ring of truth in such a detailed description of the serpent, which Sue Djabri thought could have been an African black cobra, which may have arrived though ports on the south coast, and then been carried via the busy transport of iron and timber into the forest.

In the turbulent times of the seventeenth century, stories of dragons, wyverns and worms were common in Britain. The image of a winged serpent appeared in Edward Topsell's *History of Serpents* in 1608, only six years before the Horsham story was published, and looks remarkably like the description of the St Leonard's Forest serpent, although an ancient description by Pliny the Elder in his *Natural History* also has very similar characteristics. Perhaps this is not surprising given a deep-seated human fear of predators made up of the scales, beaks, wings and claws of snakes, birds and big cats that follow us in myth throughout history and many cultures. With regard to the dragon of St Leonard's Forest it could be suggested that anyone wanting to make up a story of dragons would be likely to quote these characteristics, but as to why they should create a story about a dragon is open to speculation.

In 2012 Andrew Hadfield wrote that the story could be viewed not as an eyewitness account but as a popular sensational story. The publisher of the pamphlet, John Trundle, had form for reproducing fantastical stories, or fake news. He was connected to the theatre and so appreciated the public's desire for entertainment, and may in fact have been the author.

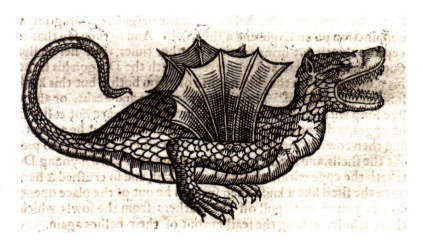

Drawing of winged dragon reproduced from Edward Topsell's *Historie of Serpents*, 1608. (© Private Collection)

Stories of dragons in folklore tend to get mixed up with the knights or saints who slay them, and this is the case with the St Leonard's dragon. A number of authors have looked at and embellished the story. A slim volume by Crookshank told of St Leonard as a brave Saxon man living in Worth and battling Normans, wolves and hard winters, building the church at Worth with his own hands, and finally settling as a much-respected hermit in St Leonard's Forest. Here he bade the angels stop the nightingales from singing, talked to the dragon and then shot it with a bow and arrow, which seems a bit harsh, and finally on his death his hermit cell disappeared to be replaced by a carpet of lily of the valley. The lily of the valley still exist in the forest, and were a great draw in Victorian times. It is likely that Crookshank embellished the myth to improve his story.

A talented young local man, Howard Dudley, wrote in 1836 that St Leonard prayed 'The adders never stynge, Nor ye nyghtyngales synge' and this was repeated by a later author with a slight twist in that the saint was asked what reward he would like for his services and he replied that he would like the eternal silence of the nightingale, which disturbed his prayers, and this was granted within the forest. Another repetition of the myth tells the old legend of St Leonard, a French hermit living in the Forest and undertaking a long and ferocious battle with the dragon, which he killed, and that lily of the valley sprang up where the saint's blood was spilt. Even today people repeat the myth that the flowers of the lily of the valley in the forest are tinged pink due to the blood of the saint. A slight deviation to this story is that the pink tinge to the flowers is from the dragon's blood, not from the saint's, given that every part of lily of the valley is highly toxic.

> DID YOU KNOW?
> Horsham holds the record for the heaviest hailstone ever to fall in the UK. Legend! On the 5 September 1958 a hailstone, weighing 140 grams and the size of a tennis ball, was travelling at a speed of 224 mph when it hit the ground. Luckily no one was hurt.

It is interesting that little today is written about the forest, but the dragon story is endlessly repeated. The dragon turns up in stories, names of public houses, sculptures and carved benches in the forest.

A recent embellishment of the dragon story mixes fact and fiction. Michael O'Leary in his *Sussex Folk Tales* tells of a deserted Indian woman, a 'black princess' living alone in St Leonard's Forest, who charmed the dragon, or knucker as he calls it, and played music for it to dance to. The name knucker is from the Saxon 'Nicor' or water monster and is connected to the name of another famous dragon that lived in a pool in Lyminster, near Littlehampton. However, back to our dancing dragon, which may not be true, but the existence of Helena Bennett certainly is, although she was neither black nor a princess. She was a well-born Indian woman from Lucknow called Halima who converted to Christianity and married a French soldier, Benoît de Boigne, anglicised to

Dragon Bench, carved by O'Neill, placed at the northern end of Mick Mills Race, St Leonard's Forest.

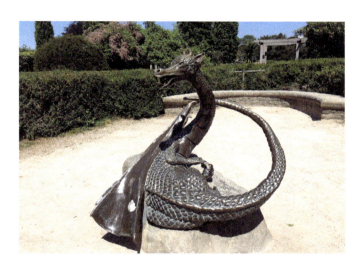

Dragon sculpture by Hannah Stewart at the centre of the maze in Horsham Park.

Bennett. She and her two children were abandoned by him in London when he went off to marry a young French heiress. After her daughter died at the age of fifteen, and with the help and support of friends in London, Helena moved to Rangers Lodge in the St Leonard's Forest. Her son was in school in Hertfordshire and rarely visited her, eventually leaving England to join his father in France. Poor Helena lived quietly in the forest with just a personal maid for company. She was kind and generous to the poor of the forest, distributing bread, and did not appear to mess with dragons. Locally born poet Percy Bysshe Shelley was moved by her story and wrote a verse based on her sad life, apparently intending to work it into a drama, but this remained an unfinished work. In older age Helena moved into 54 North Street. She is buried in St Mary's graveyard, not, as legend would have it facing Mecca, but squeezed into a full and closed churchyard, near the entrance path.

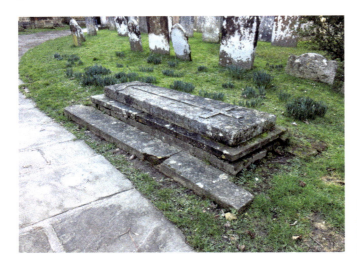

Helena Bennett's grave at the entrance to the church. (With kind permission of St Mary's Church, Horsham)

Ghosts and the Devil

One of the most chilling legends, possibly invented by smugglers, is that of the headless horseman. Stories report that it was 'woe to the luckless soul' who should cross St Leonard's Forest alone on horseback during the night, for no sooner had he entered 'its darksome precincts, than a horrible decapitated spectre' of Squire Paulett jumps up on his horse, sits on the saddle behind him, and no amount of prayers or menaces can dislodge the ghost until the rider is out of the forest. Thankfully, he does not seem to bother the modern motorist or cyclist.

Although Captain William Powlett of the Horse Grenadiers in the reign of George I inherited the forest and lived at New Lodge, he died in 1746 complete with his head, and it is not clear how or why this myth came to be. This story of the headless horseman would certainly have kept respectable people indoors at night, allowing the smugglers, or any other criminals, to go about their illegal business without hindrance.

Another legend involving smugglers was that of Mike Mills, a smuggler who lived in the forest. The Devil was determined to carry off his soul and had a few abortive attempts to do so. One dark night he confronted Mike with his contraband, who put down his tubs and challenged the Devil to a race. If he won then the Devil was to leave him alone. The Devil agreed and Mike raced away down the mile and a quarter pine tree-lined avenue of Race Hill in the forest. He outran the Devil by a quarter of a mile, so Mike's soul was saved. A 1720 mortgage names Michael Mills as occupying 600 acres of the forest including New Lodge and Coolhurst. Was he a smuggler? This would have been before the occupation of the Aldridges. Today Race Hill is called Mick Mills Race and is a clear straight track bordered by young pines in the centre of the forest, the original avenue of pines having been destroyed by a violent hurricane on 29 November 1836, and a subsequent fire.

Dorothy Hurst, writing in the mid-nineteenth century, reported that St Leonard's Forest was a famous place for smugglers to rest between the coast and London. She wrote that Mr Aldridge, probably Robert Aldridge (1801–71), remembered that when he was a boy it was a common occurrence for thirty to forty fully armed men to ride up the avenue to

Postcard of Mick Mills Race, early twentieth century.

Mick Mills Race today.

New Lodge, his isolated house in the forest. Once in the house, suppers would be laid out for them, and fresh horses made available in the stables, which suggests some complicity and perhaps financial gain from the smuggling business. However, isolated unprotected houses had little choice but to comply, and indeed although Robert Aldridge's father, John Aldridge, had been a local magistrate and a captain in the Royal Sussex Militia, he died in 1803, leaving the household particularly vulnerable to the smuggler gangs.

Ignorance, myth and superstition have always surrounded the rare genetic condition of albinism, and these are certainly alive today in some countries. People with albinism have been persecuted as a result of numerous misapprehensions: that they are ghosts and not really human; that they do the devil's work; that they are cursed or simply that they bring bad luck. In the late nineteenth century an example of this locally was the suffering meted out to Walter, the albino and epileptic son of Alfred and Charlotte Budd, landlords

New Lodge, originally St Leonard's House in the forest.

Walter Budd's memorial in the garden of the George & Dragon public house, Dragons Green. (With kind permission of landlords Simon Corby and Jon Ewers. Photograph by Alex Newton, www.tallguypictures.com)

of the beautiful old public house The George & Dragon at Dragons Green, Shipley. Worn down by the spiteful and mean treatment of some local residents, and unjustly accused of petty theft, poor Walter drowned himself at the age of twenty-six. He was buried in Shipley churchyard, but the vicar refused the monument that his parents wanted to erect by his grave in his memory. Thus, they took it home and put it in the front garden of their pub, so that all would see it as they passed to and from Shipley, and here it remains today. The heartfelt inscription reads 'May God forgive those who forgot their duty to him who was just and afflicted'.

Another story involves the albino sons of a resident of the old Elizabethan house that was Hills Place. The house has long gone, but in the orchard, there stood a Mulberry tree, now somewhere on The Crescent. The story goes that a woman gave birth to two albino sons who died and were buried beneath the mulberry tree. She died of a broken heart and is said still to haunt Hills Place, as a tall lady in white.

> DID YOU KNOW?
> There is a legend connected with All Saints Church, Roffey. In the late nineteenth century, appropriately on All Saints Day, and as the church was about to be consecrated, a beautiful white swan flew into the stone tower of the church and was killed outright, falling dead to the ground. A widow, Gertrude Martyn, had built the church in memory of her late husband, Captain Cyril Edward Martyn, and the family crest was a white swan rising from a crown. Surprisingly, Gertrude took the death of the swan as a good omen.

Ghosts seem to be the last supernatural beings to lose their grip on the landscapes of Europe, fading slowly from the imagination and only kept alive by storytelling. It is unsurprising that some of Horsham's oldest houses have ghost stories attached to them. For example, Chesworth House, childhood home of Catherine Howard, had tales of bells being rung by ghostly hands, scary shrieks in the night, sounds of horseman galloping and perhaps most unnerving of all, bloodstains that could not be erased from paving stones. All good stuff of legend.

The King and the Oak
It is well known that during the Civil War Charles II's forces were routed at the Battle of Worcester in September 1651, and he had to flee for his life. His plan was to get to the south coast and over to France where his mother was living and where he would be safe. With Parliamentary forces hot on his heels it took over a month to get to Shoreham and catch a coal barge, appropriately named *Surprise*. Early in his convoluted escape he spent a night up an oak tree in the grounds of Boscobel House in Shropshire. Nevertheless, there is a myth that he also spent a night up the Sun Oak in St Leonard's Forest. This is a good story but unlikely to be true, however big and comfortable the 800-year-old Sun

The Sun Oak on Hammerpond Road.

Oak is. The king and his companions did ride through Arundel, Houghton and Bramber, which was full of soldiers, to Upper Beeding and then on to Brighton and eventually Shoreham. This was as near to Horsham as they got. Their journey is now marked by the 615-mile footpath, the Monarch's Way, to the west of Horsham.

Myth and legend are part of Horsham's culture, and the dragon certainly looms large in this context. However, in the next chapter we look more closely at art and culture in Horsham and the people that have contributed to this over the years.

6. Arts and Culture

The best place to check out Horsham's art and culture is the Horsham Museum and Art Gallery in the Causeway. Founded in 1893 by church volunteers, it is now owned by Horsham District Council and has been under the curatorship of Jeremy Knight since 1988. It has twenty-six galleries of permanent displays and regularly changing exhibitions of art and local historical interest, plus a lovely courtyard garden. It is worth visiting as the following can only be a brief guide to the secrets of art and culture in Horsham.

Writers and Poets

When one thinks of Horsham's most famous resident, thoughts inevitably turn to Percy Bysshe Shelley, a romantic poet of mythic status. However, Horsham hardly endeared itself to the young poet, being a town that was conventional, conservative and politically corrupt in thrall to the Duke of Norfolk.

Born in 1792, the eldest son of former Whig MP Sir Timothy Shelley and his wife Elizabeth Pilfold, Percy Bysshe grew up at Field Place, Warnham, a mid-fourteenth-century house in an estate of fields and woodland. He was imaginative and fun as a child, playing with his four sisters and a young brother, and making up fantastical stories. He imagined a giant tortoise living near Warnham pond and emerging at night, a great old snake living in the gardens of Field House, and an old grey alchemist living in the loft. He had been christened at Warnham Parish Church – the twelfth-century font is still there – and attended a day school in the vicarage until sent away at ten years old to boarding school, followed by Eton where he was bullied but began to write poetry. After nine months at Oxford University he had become increasingly interested in atheism, pacifism and radicalism and was expelled for publishing a booklet on atheism. His furious father cut him off from his money and broke off all contact with him, so he only returned to Field Place and Horsham once more. This was to hear his grandfather's will read, but he was not allowed into the house and had to sit on the steps outside.

In 1811 Shelley had married the sixteen-year-old Harriet Westbrook, daughter of a coffee house owner, somewhat impulsively, and fathered a daughter before the relationship began to unravel. He wrote his first major poem Queen Mab at this time. Shelley's second wife, Mary Godwin, was not only ostracised by Sir Timothy but also by her own father. She suffered from illness and depression, losing five children with only one boy, Percy Florence, surviving. However, she wrote prodigiously and produced novels, short stories, articles, edited works and, of course, promoted Percy Bysshe's poetry. Her best-known gothic novel *Frankenstein* was published in 1818. Percy Bysshe drowned when his boat sank in a storm off Italy in 1822 and Sir Timothy eventually died aged ninety in 1844. Mary's son, Percy Florence, inherited Field Place from his grandfather and so in 1848 he and his wife, and his mother, Mary Shelley, all moved in and split their time between Field Place, their house in London and trips abroad.

Warnham Mill Pond at Warnham Nature Reserve, Warnham Road.

The Rising Universe or Shelley Fountain, which was sculpted by Angela Conner, installed at the Lynd Cross and dismantled in June 2016. (© Horsham Museum & Art Gallery (Horsham District Council))

Commemorations of Shelley in the town have been disappointing to say the least. In 1892 people found it hard to decide how to commemorate the centennial of his birth due to his atheism and radicalism, and suggestions ranged from a drinking fountain to a library or museum. In the end they decided on just a plain plaque in the parish church, and half-hearted celebrations that even George Bernard Shaw criticised. The bicentenary commemoration in 1992 was marked by a major exhibition at Horsham Museum who now have the best Shelley collection in the country. There was also the installation of the Shelley Fountain, or Rising Universe, at the Lynd Cross. It was a large kinetic water sculpture by Angela Conner including a plaque with the lines from his poem 'Mont Blanc'. The sculpture with its falling water was good fun while it worked but it was controversial and costly to maintain. It became an iconic Horsham image used in the beginning credits of BBC One's *South East News*. However, its demise came in 2016 when it was felt to be just too expensive to run so in 2018 the basin was planted with birch trees and the main structure scrapped.

Less well known than the Shelleys but living around the same time was Eliza Cook, poet and journalist, who was born on Christmas Eve 1812 in Southwark, the youngest of eleven children. Her rather large family moved from London to a farm in St Leonard's Forest when she was around nine years old. She began writing poetry as a child and first published when she was just seventeen. As an adult she moved back to London, and was published in magazines and journals. Her first poetry collection was called *Lays of a Wild Harp,* which was published in 1835. She became a popular poet and was compared to Robert Burns. Her interests also lay in democracy and reform, and she became a prominent chartist and champion of freedom for women. For five years she published a weekly journal full of household hints and tips but also polemic essays and radical ideas, a bit like a blog might be today. Her partner was the American actor Charlotte Cushman.

> DID YOU KNOW?
> Buffalo Bill's Wild West show hit Horsham on 15 June 1904. Schools closed and people turned out in their droves for the afternoon and evening performances at Jew's Meadow, now the Merryfield Drive area, west Horsham. What they saw was extraordinary. Buffalo Bill, or W. F. Cody, showed his skill by shooting down thrown objects while riding at full speed. From his team of US veterans, cowboys, Cossacks, Mexicans, Arabs, Japanese, and Native American Indians there were feats of horsemanship, marksmanship, lassoing, bicycle leaps of 56 feet, juggling, acrobatics and staged attacks on a train and a stagecoach. It was all enthusiastically received.

Now back to more well-known writers and poets like Hilaire Belloc. He was born on 27 July 1870 in Paris, his father French and mother English. Due to the outbreak of the Franco-Prussian War the family moved to England and settled in Slindon, Sussex. Although Hilaire kept his dual French and British nationalities and enjoyed holidaying in France, he lived his whole life in West Sussex, moving when he married to King's Land, or Kings Mill, in Shipley near Horsham. He lived almost fifty years in this brick house and windmill, parts of which dated from the fourteenth century.

Hilaire Belloc was an incredibly prolific writer, producing more than 150 volumes in his lifetime. He was passionate for the Sussex countryside and being strong and fit he embarked on many long walking holidays with male friends or alone. Notably his most successful travel book was based on a walk from Lorraine in France, where he had completed his military service, over the Alps to Rome. *The Path to Rome* was published in 1902 and was an entertaining account of his reflections on the landscape, people he met and his experiences. Another popular book was *The Four Men: a Farrago* in which four imaginary characters walked from Robertsbridge, 10 miles north of Hastings in East Sussex, to Harting in West Sussex, around 12 miles north of Chichester, taking in his beloved South Downs. Along the way they pass through Lower Beeding and enter the Crabtree pub where his *West Sussex*

Drinking Song was sung. Belloc loved to hear his own songs sung in chorus and had a good singing voice himself, a high tenor. The characters in this story also visit The Fountains Inn in Ashurst where they enjoy the beer. Perhaps his most popular poem, certainly hereabouts, is 'The South Country' in which he wishes to be back in 'the great hills of the south country, drinking with the men that were boys when I was a boy'.

Living near Belloc in Shipley was another poet, Wilfrid Scawen Blunt, better known perhaps for his establishment of an Arabian horse stud at Crabbet Park, near Crawley. Born of wealthy parents at Petworth House in 1840, he married Lord Byron's granddaughter and together they travelled widely in the Middle East. Although he served in the Diplomatic Service for ten years, he was opposed to British imperialism and was a political activist and essayist. He was regarded so well by poets of that time that Ezra Pound and W. B. Yeats organised a roast peacock dinner for him at his home in January 1914 as a homage to an older fellow poet.

The First World War poet Edmund Blunden grew up in Yalding, Kent, one of nine children of school teacher parents, but after he won a scholarship to Christ's Hospital School he came to know this area well, and began to write his first poetry at the school. He should have continued his education by taking up a scholarship to Oxford but instead the First World War intervened. He enlisted as a lieutenant with the Royal Sussex Regiment, having cycled from Horsham to Chichester to do so. Thankfully, he survived the awful battles of Ypres, the Somme and Passchendaele, and was awarded the Military Cross for conspicuous gallantry in action. There followed a successful career as a critic, poet, author and professor of poetry at Oxford, succeeding his friend Robert Graves. He died in January 1974 but will be remembered alongside Sassoon and Owen as one of the great First World War poets.

One could claim Horsham as an inspiration for Arthur Conan Doyle. He lived in his later years near Crowborough, but two of his Sherlock Holmes stories mention Horsham and district. The first, *The Five Orange Pips*, has his protagonist, John Openshaw, arriving at Holmes' London home one dark and stormy night. Holmes deduces from the mix of clay and chalk on his shoes that he is from the South West, and Openshaw admits he is from Horsham, and thus the story unfolds. It was published in 1892. One of his later stories,

DID YOU KNOW?
After serving in the army in Korea, Michael Caine returned to London and worked in a butter factory before getting his first acting job in repertory theatre in Horsham. He played small parts and made tea, being paid £2 10s a week. This was sadly ended by a bout of cerebral malaria that he had contracted in Korea. He never returned as the company folded.

The Adventure of the Sussex Vampire, published in 1924 in the *Strand Magazine*, was based in Lamberley, south of Horsham, perhaps based on the real village of Amberley. Conan Doyle did in fact have some connection to this district in that his sister had married E. W.

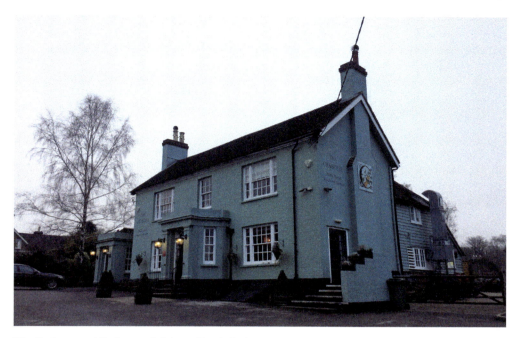

The Crabtree public house, Brighton Road, Crabtree.

Hornung, the author of Raffles stories, and they lived at West Grinstead Park, the other side of the A24 from the Knepp estate, south of Horsham town.

As you walk up the Causeway towards the church in Horsham, you might notice a house on the left-hand side that has a blue plaque on the wall. This is the house where Hammond Innes lived from 1919 to 1924. He was born in No. 68 Clarence Road, and the family moved to the Causeway when he was six. He went to Cranbrook School, leaving at eighteen to be a journalist and write thrillers in his spare time. The Second World War intervened and he joined the Royal Artillery, but he picked up his writing again when peace came. He wrote adventure stories based in exotic places, all of which he visited and researched with his wife, Dorothy May Lang. His most popular books were made into films like *Campbell's Kingdom,* which starred Dirk Bogarde. Innes died in 1998 having spent most of his adult life in Suffolk.

There are of course many modern writers in Horsham, and a thriving Horsham Writers Circle, established in 1987 to encourage writers of all sorts: short story writers, poets, and fiction and non-fiction writers. A special mention should be made of Julia Donaldson CBE who created *The Gruffalo* for children. She lives near Steyning and is patron of the 2019 Horsham Year of Culture. A writer that engenders similar public affection is David Sedaris, an American humourist and author who has also come to live among us in Horsham District.

Before we leave writers altogether, some mention should be made of the Horsham diarists and local historians that have added so much to our knowledge of eighteenth- and nineteenth-century Horsham. First up is Sarah Hurst, whose diaries, 1759–62, have been interpreted and published by local historian Sue Djabri. Sarah was the daughter of

The plaque on Hammond Innes' house in the Causeway.

a somewhat grumpy tailor with a shop in the town. She worked in her father's shop, kept the accounts, travelled up to London, visited friends in Sussex, and waited for her soldier fiancé to return home. He was Henry Smith of the Marine Corps, fighting the French in Canada as part of the Seven Years War. Her diaries were not intended for publication but they give a wonderful insight into a young woman's life and thoughts in the small market town of Horsham in the mid-eighteenth century.

Very different were the diaries of John Baker, a wealthy man who came to live at Park House on North Street in 1771. From this date he wrote in a mixture of English, Latin and French about the doings of his neighbours and minor Sussex gentry. His descendant, W. S. Blunt, transcribed his diaries, later published in 1933 by Philip Yorke, and was quite disparaging about Baker's hedonistic lifestyle of visiting friends, drinking and eating, listening to music, attending fairs, shooting and watching a lot of cricket on the common.

Next, a young man, Howard Dudley, wrote *The History and Antiquities of Horsham*, published in 1836. He researched, wrote, illustrated and printed his first book when he was just fifteen. A year later he produced his history of Horsham, again doing all the work himself, including the printing and binding. Thankfully this rare book was reprinted by Jury Cramp in the 1970s. Dudley describes the big houses of the day, and the churches, but also gives some nice details such as the disruption caused by the newly installed gaslighting in the streets. He also mentions that there were thirteen inns in the town, of which barely five survive today. Impressively he notes that the stagecoach, the Horsham and London Star, ran to London and back every day, taking around five hours to get from The Swan, West Street, to Holborn in London, and returning in the afternoon. Also mentioned are daily coaches to Brighton, Worthing, Windsor, Oxford and Reading. What service!

Henry Burstow was a poor cobbler and an oral history of his memories, called *Reminiscences of Horsham*, were collected, and perhaps added to by William Albery, saddler, calligrapher and author who we came across in chapter three. Burstow was a locally well-known bell ringer and folk song singer with a superb memory. He knew 420

Park House, North Street.

folk songs by heart and two of these had 155 verses each. Some of his memories of wife selling in Horsham market are mentioned in chapter two.

A Horsham memoir/diarist of the nineteenth century, was Henry Michell, a middle-class, mid-Victorian entrepreneur. He was mentioned in chapter three as a highly successful brick maker and brewer. Like Sarah Hurst he did not write for publication but rather as a memoir for himself, his family and later generations. So, it is of great help that Kenneth Neale has edited and interpreted the diary for us in his 1975 book *Victorian Horsham: The Diary of Henry Michell 1809–1874*.

As far as straightforward Horsham local histories go, the first to follow Dudley was Dorothea Hurst, descendant of the diarist Sarah Hurst and sister of Robert Hurst MP, member of a by now wealthy property-owning family. She published *Horsham: Its History and Antiquities* in 1868, initially anonymously. She provided some illustrations herself but other local artists contributed, mainly providing contemporary views of Horsham buildings. She shared anecdotes about the town as well as outlining its historical development. Dorothea updated her book in 1889, adding her name, and noting that there had been substantial changes in the town in the intervening thirty years.

The saddler William Albery, who had collected Burstow's memories, wrote two more books of huge importance to Horsham's history. First, he produced the complex and detailed political history *A Parliamentary History of Horsham 1295–1885*, published in 1927

with an introduction by Hilaire Belloc. Horsham had been a notorious rotten borough until reform and this book explained the elections and the fraud, step by step. Some years later in 1947 he published a more general book about Horsham's history, *A Millennium of Facts: The History of Horsham and Sussex 947–1947*, which continues to be of enormous assistance to anyone wanting to know more about Horsham history. You can find it in the local library.

Artists and Musicians

There is some evidence of artistic talent in Horsham in the late sixteenth century, following the refurbishment of an old burgage building at Market Square and the discovery of painted floral designs between timber posts, although these are possibly copied designs.

Further evidence is limited, until William Burrell of the Knepp estate, now famous for its rewilding project, employed Swiss artist Samuel Grimm to make drawings to illustrate Burrell's historical research, which covered much of Sussex. Grimm arrived in Horsham in June 1781 and completed eighty-four sketches of local country houses, which are today archived in the British Library. Apart from their obvious artistic merit they are particularly useful for providing historical detail of houses that have since been altered or demolished.

Thomas Mann, who produced a number of sketches of Horsham town, was born in North Street in 1834. His father was a successful pharmacist who had invented a popular medicine. However, despite his talent for art, Thomas took over his father's business rather than further his artistic career. His son George Mann was also a good artist.

Towards the end of the nineteenth century the artist William Dendy Sadler was brought up in Horsham. He studied art in London and Germany, later exhibiting at the Royal Academy. He painted domestic daily life, capturing everyday scenes and people. Another painter who lived in Horsham around the same time as Sadler was John Guile Millais, the fourth son of John Everett Millais and Effie Gray, well-known members of the Pre-Raphaelite group of earlier painters. The local girls' secondary is named Millais School after John Everett Millais. John Guile was keen on hunting and shooting, and as a good Victorian naturalist he collected over 3,000 specimens from his exploits. He developed into a noted ornithologist, producing excellent bird paintings, many based on

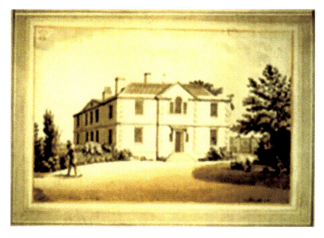

Drawing by S. H. Grimm of New Lodge House, 1787. (© The British Library Board, Add MS 5673 f68, No. 123)

his collection of bird and animal skins in his personal museum at Compton's Brow. He also had an interest in horticulture, in particular the hybridisation of rhododendrons, a love he shared with his friend Edmund Loder of Leonardslee, and indeed, Loder's neighbour at South Lodge, the ornithologist and naturalist, Frederick DuCane Godman. Millais wrote two authoritative books on rhododendrons and one on magnolias. Sadly, his garden and house did not survive after his death. His son, Raul, was born in Horsham and was also a good artist, particularly of horses. Raul accompanied Ernest Hemingway to Spain and produced sketches and paintings from what he saw. However, he had no truck with Picasso and modernism.

DID YOU KNOW?
On 3 August 1963 the Rolling Stones performed at St Leonard's Hall, Cambridge Road, Horsham, for an hour and a half for which they received the grand total of £50. They appeared with the local resident band Peter and the Hustlers, later known as the Beat Merchants. The Stones had just released their first single 'Come On', which entered the charts a few days earlier and went on to reach No. 21.

Another Horsham artist who was keen on horses and hunting was Dr Geoffrey Sparrow. Born in Devon, he studied medicine until serving in the First World War where he gained the Military Cross. He joined a Horsham GP practice on returning from the war, pre-NHS, joined the Crawley and Horsham Hunt and began to paint. He served again in the Second World War and then retired. Many of his paintings and sketches are held by Horsham Museum and Art Gallery and show hunting scenes and caricatures.

An artist of considerable talent but of a completely different style was Vincent Lines. Born in Dulwich in the early twentieth century, he studied at the Royal College of Art. In 1935 he came to Horsham as principal of Horsham School of Art. He painted with watercolours and pen and ink, often in the open air, interpreting local buildings and scenes.

Just before the First World War in 1913 Frank Brangwyn RA visited Christ's Hospital School, as he had been commissioned to design and paint sixteen wall murals in the chapel with scenes from the Bible. This was quite a coup, as Brangwyn was a very well-respected artist, particularly known for his bold and colourful murals.

A local artist and sculptor of particular note was Edward Bainbridge Copnell MBE, born in South Africa in 1903 but coming to Horsham as a child. His family was artistically prolific: his father was a photographer, his uncle a portrait painter and his son, John, a painter. Such was the family's renown locally that Copnell Way, off the Carfax, was named after them. Edward wrote a book on sculpture and an autobiography but he is best known for his large and arresting sculptures. His Crucifixion of Jesus was originally on St John the Evangelist Church, Springfield Road, but was taken down as it apparently scared the children, and is now in Horsham Museum and Art Gallery. Another of his

sculptures, *The Astronomer*, was given to Collyer's College by his sister, Phyllis Millar, in 1979 and now sits in the upper quadrangle.

There are a good selection of bronze sculptures in the town like the swans in Swan Walk, William Pirie in his donkey cart in Piries Place, and the sundial with its thirty depictions of Horsham over time, all by Lorne McKean, with Edwin Russell and Damien Fennell also working on the sundial.

An award-wining local sculptor working and teaching today is Jon Edgar of Fittleworth. He is currently undertaking an exciting Portland stone sculpture at the new Highwood Village, north-west Horsham, where there is the opportunity of public participation. He is best known for works in stone, and clay or terracotta portrait heads.

In 1928 Mr J. T. McGaw, who was an aspiring artist and landowner in St Leonard's Forest, founded the Association of Sussex Artists as a showcase and encouragement to a diversity of local artists, be they professional or amateur, self-taught or art school, painters, potters or sculptors. All were to be encouraged. One of its supporter members in the early days was in fact Sir Frank Brangwyn. The association continues today, and holds an exhibition each year in August at the Drill Hall in Horsham adding enormously to the artistic culture of the town. Another artistic asset is the Horsham Artists Open Studios (HAOS) which is an informal group of artists of all types living and working in Horsham District who organise an Art Trail and Contemporary Art Fair every year.

The Astronomer, Collyer's College, by Bainbridge Copnall (1903–1973), president of the Royal Society of British Sculptors in 1961–66. (With kind permission of Collyer's College)

Jon Edgar working on his sculpture at Highwood Village in February 2019. (Follow blog on www.horshamsculpture.wordpress.com)

DID YOU KNOW?
Marilyn Monroe visited Horsham in 1956 with her third husband, the playwright Arthur Miller. She was in the UK filming *The Prince and the Showgirl* with Laurence Olivier at Pinewood Studios. They stopped in Horsham en route to Brighton, to buy a full length tweed coat from R. Quasnitschka's shop in the Bishopric. There is also a rumour that she visited earlier in 1953/54 and stayed at a farmhouse in Slindon near Arundel, although sceptics say this may have been Diana Dors, Britain's answer to Marilyn Monroe.

It is good to know that botanical art is thriving in Horsham today. Wonderful painters like Jill Coombs and Leigh Ann Gale run workshops for those who aspire to botanical watercolour painting. Leigh Ann has recently produced a very comprehensive book guiding one through the stages of painting plants called *Botanic Illustration, The Complete Guide,* and both she and Jill have placed pictures in Horsham Museum and Art Gallery. Such inspiration trickles down and there are lots of good amateur botanic artists such as Heather Glenny, who produces cards from her paintings. In order to foster botanic illustration further there has been the recent establishment in 2019 of The Horsham School of Botanic Art.

Burstow in his *Reminiscences* wrote that he did not know whether bell ringing or song singing gave him the greatest pleasure throughout his life. Bell ringing in Horsham certainly has a long tradition, but is not so prevalent today as it was in Burstow's time when there were peals in all church services, on the hour, to mark the old year ending and the new beginning. Even so, Burstow mourned the loss of the old bell ringers who could do even better with elaborate peals. Burstow memorised folk songs from his father, from bell ringer friends, the shoemakers and craftsmen he knew, song sheets, and of course from those sung in the pubs and inns of the district. He was asked to sing regularly and

Botanical illustration of *Camellia x williamsii* 'Bow Bells'. (© Leigh Ann Gale)

his largest audience was at a Silver Band concert in 1908. Not surprisingly he attracted the attention of Lucy Broadwood, a keen collector of folk songs and founder of the Folk-Song Society.

Lucy belonged to the family of successful piano manufacturers John Broadwood & Sons, who had gifted Beethoven a new triple-stringed piano that was later played by Liszt. Her great-uncle had bought the Holmbush estate on the edge of St Leonard's Forest in the early 1820s. His elder step-brother owned Lyne House, north of Rusper, and this remained the family home that Lucy grew up in. She was an accomplished piano player and singer with an interest in old English folk songs, hence her setting up of the Folk Song Society. Her neighbour, the composer Ralph Vaughan Williams, said about her that 'she was England's greatest folk music scholar.'

The Broadwood Morris Men were established in 1972 and took Lucy's name in honour of her service to saving folk song tradition. She wrote of her delight in seeing an old dancer at Lyne House on May Day in the early 1870s and so in tribute the Broadwood Morris dance at Lyne every May Day in front of the house, and put a garland of flowers by her memorial in Rusper Church.

Another Horsham musical tradition is that of the brass band. In the early nineteenth century there is mention of bands playing at various local functions. William Albery, who we have met before, played the cornet and co-founded the Horsham Recreational Silver Band in 1900. In the thirties they were regarded as the third best brass band in the country. Their name was changed to the Horsham Borough Band, which is still going strong today, playing at concert halls, in contests, with other bands, and of course in Horsham town in the bandstands in the park or on the Carfax.

Of some fame in classical circles was Wilfred Brown. Born in Horsham in the 1920s, he became an acclaimed tenor singer. A lifelong Quaker, he was educated at Collyer's, Christ's Hospital School and then Cambridge. Initially he became a teacher of languages before giving himself over to a life of professional singing. He was a good friend of the soprano Dame Janet Baker and guitarist John Williams, and made regular recordings with

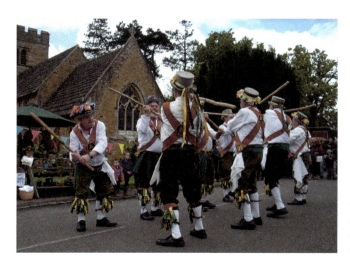

The Broadwood Morris Men dancing outside Rusper Church. (With kind permission of Andy Slade)

the BBC. In 1957, when Ralph Vaughan Williams set ten of William Blake's poems to music for voice and oboe, the singer he wanted for its first performance was Wilfred Brown. Sadly, Brown died far too soon at the age of forty-nine.

Horsham continues to have a vibrant music scene with local bands in public houses like the Malt Shovel and the Kings Arms. Horsham Park hosts the Garden Music Festival and Battle of the Bands in the summer each year, and of course there are choirs: the Christ's Hospital Choral Society, the West Sussex Philharmonic, Chamber Choir, InChoir, Rock Choir and Big Notes. Added to those is the Horsham Music Circle, who organise concerts and chamber music.

Photographers and Film

Thomas Honywood appears to have introduced photography to Horsham in the mid-nineteenth century. He was an interesting man, captain of the volunteer fire brigade, artist, archaeologist and inventor of a new photographic process that he called nature printing. Honywood was an amateur. Professional photography did not come to Horsham until around the 1860s when William Clark set up a studio in West Street, quickly followed by Thomas Bayfield in North Street. These pioneers were followed by a dozen more before the First World War. In the early twentieth century there was a Horsham and District Camera Club, and then in 1949 Horsham Photographic Society was formed, which is still going strong today.

Where the United Reform Church now stands on Springfield Road there used to be the first of Horsham's cinemas. It was called the Gem and from the few memories recorded about it, appeared to be rather basic. It closed in 1912 but others sprung up at around that time: the Electric theatre in 1911 and the Central Picture Hall, later the Winter Garden cinema, which was patronised by Canadian soldiers billeted in Horsham during the First World War. In the 1930s the Odeon cinema opened on North Street with its distinctive pillar lighthouse at the entrance, later called the Classic and Mecca before being demolished in 1981. The Ritz cinema was built next to the Odeon site and opened in 1936, renamed the ABC in the 1960s. The original Capitol used to be a rather grand Italianate building on Swan Walk, where Marks and Spencer is now. It was set up in 1923 by Major R. C. G. Middleton and his Blue Flash Cinema Company to employ ex-service bandsmen. However, in 1983 it was demolished to make way for the Swan Walk shopping mall. Around the same time the district council bought the ABC building on North Street, refurbished it and renamed it the Horsham Arts Centre. It was refurbished again in 2003 at a cost of £7 million to provide a 410-seat theatre, two cinema screens, a studio theatre, a meeting room, gallery space, and a café and bar, and renamed The Capitol after the original cinema. In 2018 it was named by TripAdvisor as one of the best entertainment experiences in the UK, and is now in their hall of fame for excellence. The Capitol is no longer the only town cinema and theatre as the Everyman Cinema opened in Piries Place in 2019.

One should perhaps mention television connections. Belloc's King's Mill in Shipley was used in the mystery drama *Jonathan Creek*, starring Alan Davies and Caroline Quentin, at the end of the 1990s. Harry Enfield, comedian, was born in Horsham and went to Collyer's Sixth Form College and then the University of York. One of his comic characters, Stavros, was said to have been based on a local Greek Horsham restaurant owner. Rather excitingly

The Capitol theatre and cinema, North Street.

there is a film company in Horsham, Fact not Fiction Films, which was established in 2006 and now produces feature and short films of public interest. There is also a media video company called Silvertip Films, established in 2005 and producing promotional videos and event shoots. In 2017 two Media Awards were won by another Horsham based company, RMV Productions, showing great creativity and skill working with television, record labels and businesses.

DID YOU KNOW?
The muse of the Revd Charles Dodgson and the real Alice in Wonderland, Alice Liddell, spent the first few days of her honeymoon at Sedgwick Park, on the outskirts of Horsham. She had married Reginald Hargreaves, brother of Emma Henderson, who owned Sedgwick with her husband. Alice wrote later to Emma thanking her for their stay at Sedgwick and doubting whether the house would again shelter such 'foolishly happy creatures'.

We must now leave this upbeat chapter on the arts and culture and move to rather more sombre things. We delve into the past again, when Horsham was the centre of justice for crime and punishment, having a court and a gaol, and a hanging gibbet, so for grim secrets read on.

7. Crime and Punishment

A Famous Case

The most notorious criminal connected to Horsham in the twentieth century was undoubtedly John George Haigh, the Acid Bath Murderer. A Londoner, he had rented a workshop in Leopold Road, Crawley, where he shot his sixth victim, Mrs Olive Durand-Deakon, and dissolved most of her body in a vat of sulphuric acid, his usual *modus operandi*. He was arrested in Crawley, held in police cells before being held in No. 2 cell in Horsham Old Town Hall, pending the preliminary hearing upstairs in the court, now Bill's restaurant. The hearing on the 1 April 1949 lasted two days with thirty-three witnesses, and as he had already confessed there was little chance that he would be found not guilty.

The only thing to be decided when it came to the full hearing at Lewes Crown Court was whether he was insane or not. Having admitted everything, Haigh had apparently thought that because there were no bodies he could not be convicted of murder. He had dissolved all six of his victims in barrels of acid and poured the result down the drain and any sludge onto waste heaps. However, his assumption was not correct as there was enough circumstantial evidence to convict him of murder.

His plan then was to plead insanity and avoid execution by being convicted of manslaughter rather than murder. He therefore came up with all sorts of gruesome

The old town hall, now Bill's restaurant, in Market Square.

details like having nightmares of trees dripping blood, and drinking his victims' blood after he had killed them. The newspapers of course loved all this and went to town on the inhuman vampire monster, one editor actually going to prison himself for contempt of court for publishing lurid stories while the trial was in progress.

Far from being insane, Haigh was in fact an intelligent and manipulative fraudster who killed his victims in cold blood in order to access and spend their wealth, which he did prodigiously by gambling and high living. The court was not fooled and he was sentenced to execution, which was carried out at Wandsworth Prison on 6 August 1949.

The Courts

Up until modern times Horsham was an important centre for courts, and other institutions of justice such as the gaols and police. Gradually it lost this status due to a number of factors, so that even within the last few years the remaining police station and magistrates' court has lost work and personnel as a result of budget cuts, and their buildings are now likely to be redeveloped.

There is, however, an impressive history of justice being dispensed in Horsham since it became a borough, and records, albeit incomplete, exist from the fourteenth century that detail almost eighty cases, twenty-two being criminal. There were two main types of court: the assizes and the quarter sessions. Although both criminal and civil cases could be heard in both courts, the quarter sessions were the lower court that dealt also with administration, and only the higher assizes court was able to sentence more serious cases.

The town where the assizes in Sussex sat could vary, although they were always held twice a year in March and July or August, known as the Lent and Summer assizes. Since the start of the eighteenth century the assizes were always held in the summer in Horsham, alternating with Lewes, and the Lent ones at East Grinstead until 1800, when these also came to Horsham.

Court buildings in Hurst Road.

DID YOU KNOW?
The arrival of the two assizes court judges in town in the eighteenth century was quite an occasion. The day before the court opened the High Sherriff of Sussex would arrive in his four-horse coach with uniformed footmen and ten or twelve javelin men and trumpeters all dressed to the nines, mounted, carrying a wooden rod, the javelin, 7 feet long with a spear at the end. In the early evening they would all ride out, with other town officials, to meet the judges on the boundary of the borough and present them with the keys to the borough. The judges would then be escorted into town as church bells rang and crowds of people followed them.

The Old Town Hall, now Bill's restaurant, where the courts were held was originally the Market House and, as its name implies, the ground floor consisted of open arches where the market would take place. Above this was a room where the court would sit, although when used as a court building the arches were boarded up as all the space was needed. One can imagine how chilly this would be in March at the Lent assizes. The unsuitability of the building caused problems and, given the provision of a new Court House in Lewes, complaints were heard. The assizes brought a lot of business into Horsham, so in 1812 the Duke of Norfolk paid for improvements to the building, such as enclosing the ground floor and putting up a new north façade, which included his newly created coat of arms complete with dragon's tail. This kept the court in Horsham for a while, but there were mutterings about how expensive accommodation was in the town as well as how little was available. Clearly the judges' entourage, lawyers and suchlike took a lot of accommodating, although one hotel that benefitted was the King's Head, opposite the town hall and now an ASK restaurant. Eventually the assizes were lost permanently to Lewes in 1830.

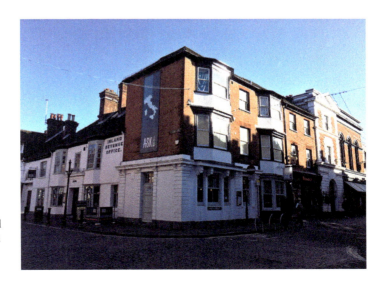

ASK restaurant in the old Kings Head buildings, on the north-west corner of East Street.

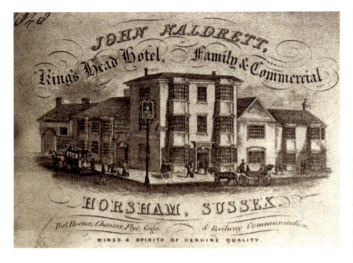

1847 engraving advertisement for the Kings Head Inn, reproduced from W. Albery's *A Millenium of Facts,* 1947. (© Horsham Museum & Art Gallery (Horsham District Council))

The quarter sessions, a bit like the magistrates' courts of today, were held every January, April, July and October. The Sussex towns in which they were held varied, but from 1722 they were held regularly at Midhurst, Chichester, Horsham and Petworth. Again, they brought wealthy people and business into the town, as well as lots of political talk and scheming. By the end of the nineteenth century when the building, now known as Bill's or the Old Town Hall, fell into further disrepair there was real fear that the quarter sessions might also be lost. However, after some convoluted negotiations, and on the promise of repairs being done, the Duke of Norfolk handed over the freehold of the town hall in 1888 to the Local Board, later the district council. The building was refurbished with cells, stone stairs and more comfortable courtrooms. The north wall was retained and the clock added.

The Gaols

Gaols were needed for holding prisoners both before and after sentencing by the Horsham courts. Prison was not initially regarded as punishment in its own right through the loss of liberty, except of course for debtors, who were held until they could pay off their debts. This was all a bit pointless as, unless their family could stump up the necessary, they could not work to repay their debts while in prison, a catch-22 situation. An example of this was the sad case of Simon Southward, who died in prison in 1810, having spent forty-six years in gaol for a small debt. Charles Dickens, the author, was an enthusiastic advocate of debtor prison reform, and imprisonment for debt eventually ended in 1869.

There were three successive gaols in Horsham. The first was on the corner of Carfax and North Street, more or less behind where the local shop Crates is. This was a large burgage site called Butlers, and originally owned by the Lintott family. Nicholas Lintott was appointed the gaoler in 1589 and managed to preside over eight gaol breaks. The Lintott burgage site included the gaoler's house with the prison behind, and two tenement buildings. In front of it, more or less where the bandstand is now, was a patch of land known as gaol green on which the stocks were set.

Eventually it was recognised that a new prison was needed, so another burgage plot on the north Carfax was identified, the site now being occupied by the Halifax Building Society. Building the prison began in 1640, but it was badly supervised and shoddy work was done, and it was always needing repair, as prisoners kept escaping. The gaol was much criticised by John Howard, the prison reformer, when he visited in 1774, saying it was filthy, plague-ridden and unsafe. At the same visit Howard managed to foil a planned gaol break.

The Duke of Richmond took up the cause and championed a new model prison to be built in East Street the following year. The new gaol was to have an infirmary, chapel, exercise yards, individual cells and separate facilities for men and women. New rules and regulations were to be established, which included no alcohol, the provision of which, unbelievably, had been a lucrative previous business for the gaolers. This new Horsham gaol was the first model prison in England and the first to have individual cells.

Once the assize courts moved to Lewes, the numbers of inmates in the new Horsham gaol declined and it was obvious such a large building could not be sustained. There was talk of the prison being used to house the mentally ill, but this idea was vetoed. So, in 1845 the whole site was sold to Henry Michell, who reclaimed all the valuable building materials, the bricks, paving and timber, but not before he had opened the gaol to

The replica stocks and post on the Carfax.

The Halifax Building Society on the approximate site of the second gaol in the Carfax.

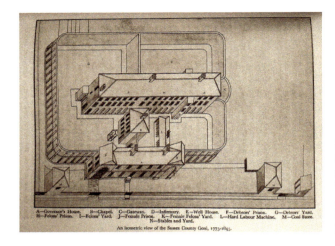

An isometric view of the last county gaol in Horsham, 1775–1845, reproduced from W. Albery's *A Millenium of Facts*, 1947. (© Horsham Museum & Art Gallery (Horsham District Council))

sightseers, and very popular it was. Of course, the quarter sessions still needed somewhere to hold those arrested and so Michell built a police lock-up to the east of the gaol site. The site itself was later to disappear under the railway line and the iron bridge of East Street.

Before it was demolished, the last hanging in Horsham took place at the gaol in April 1844. The condemned man was John Lawrence, a twenty-four year old from Kent who had stolen a carpet from Brighton. He was arrested and taken to the Brighton police station whereupon he murdered the Superintendent of Police with a poker. Burstow, the folk singing cobbler, witnessed the hanging and describes the scene in his reminiscences. The hanging was scheduled for a Saturday and coincided with one of Horsham's fairs and so there were plenty of people in town. Burstow estimated that a crowd of 3,000 thronged the streets around the new gaol, with people selling gingerbread, oranges, beer and broadsheets with poems and songs about the murderer. As a final indignity John Lawrence's body was exhumed when the gaol was demolished and displayed in the Queen's Head stables for whoever wanted to see it for tuppence a go. It was later reburied in the western part of St Mary's graveyard where other executed prisoners had been buried.

The Police

Horsham was quick in establishing a police force once it was legally permitted. In 1829 Sir Robert Peel created the metropolitan force in London, and ever after the police have been called 'bobbies'. A few years later the right to have a police force in provincial towns was granted, so in October 1839 Horsham employed its first bobby. Previously there had been voluntary parish constables with little power but who were awfully good at 'beggar-pooking', which, as Burstow described, was basically hassling aggressive beggars out of town. There were rules for the job but it was becoming increasingly onerous to keep the peace and make arrests. The first full-time police officer was John Coppard Gower, who in his uniform and top hat, instilled fear into the young Burstow.

Around seven years after this appointment, the first police station was built in East Street, near the new county gaol building. It included a lock-up and was staffed by one superintendent and two policemen. However, towards the end of the century a

Above left: Sketch of Horsham's first full-time police officer, J. C. Gower, reproduced from J. Knight's *Horsham's History*, Vol 2, 2006. (© Horsham Museum & Art Gallery (Horsham District Council))

Above right: Peel House, the old police station in Barttelot Road, originally Sussex Police Headquarters, which is now offices and flats.

Gates to Peel House still displaying the shield of Sussex Police.

new police station was built in Barttelot Road, off East Street, which became the main headquarters for the West Sussex Constabulary between 1897 and 1922. Unusually it sported a red light outside the station rather than a blue one, to signify that it was a headquarters. This solid Victorian building is still in existence, although it has been converted into offices and flats. It is called, appropriately, Peel House.

As the organisation of the police changed and merged, the West Sussex headquarters moved to Chichester and then to Lewes in 1968. Around this time the site on Hurst Road,

next to the hospital, was developed for new institutional buildings such as the police station, court, ambulance and fire station. As mentioned earlier these are now earmarked for fresh development.

The Punishments

Early records from the first Horsham gaol show both men and women held on remand for such crimes as forgery, debt, the stealing of horses, cattle or sheep, murder and infanticide. All of life went on in the prisons, including marriage, birth and death.

At this early time dissenters such as Quakers were imprisoned for itinerant preaching. They were seen as a threat to the existing order, as they disagreed with the authority of both Church and State, refused to pay parish taxes, take an oath, bear arms, or take off their hats in respect to local gentry. They also treated women equally, allowing them to minister. Their views were perhaps a little too democratic for the seventeenth century.

One of Horsham's best-known Quakers, Ambrose Rigge, came from Cumbria to spread the new ideas in the south-east. He knew George Fox, founder of the Quakers, and was friends with William Penn, another local Quaker of Pennsylvania fame William Penn lived at Warminghurst and was involved in the purchase of a farmhouse at Coolham for use as a Friends Meeting House, now known as the Blue Idol. Ambrose Rigge was abused as a vagrant in Southampton and imprisoned in Winchester, released and threatened with branding and a fine if he returned. He moved on but was arrested again in Hurstpierpoint, the rector there being particularly vitriolic towards him. He was imprisoned in Horsham gaol and sentenced in 1662 to imprisonment at the king's pleasure and all his goods confiscated. This meant that he had to obtain the king's pardon to get out, thus he stayed in Horsham gaol for over ten years, and during that time he married a fellow Quaker prisoner, Mary Luxford.

DID YOU KNOW?
The gallows became known as the notorious 'Horsham Drop' following a bungled hanging and the subsequent development of a moveable gibbet. It was made of timber and canvas, and painted black with a trapdoor beneath. When the bolt was thrown the body dropped and life extinguished. Such a sight drew so many spectators that the days of execution were known as 'Hanging Fairs'.

Prisoners were very dependent on the whims of the gaoler and poor Ambrose Rigge suffered considerably at the hands of Richard Luckins the younger, who shut him in small cells, took away his bedding and was loath to let other friends bring him the food and drink on which he was dependent. Many other Quakers were imprisoned in Horsham gaol, but none for as long as Ambrose Rigge, who did eventually get his pardon in 1672. He stayed in Horsham for a year and then settled in Surrey. The Act of Toleration in 1689 prevented further imprisonment for dissenters.

There were specific Houses of Correction in the County, for example, at Petworth and Lewes. Horsham did have one, but it is not well documented and was thought to

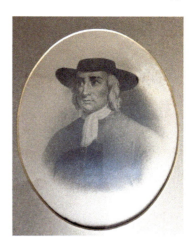

Picture of Ambrose Rigge, displayed in the Horsham Friends Meeting House. (With thanks to West Weald Quaker Area Meeting)

have been near the second gaol on the Carfax. There was usually some sort of work to be carried out by the prisoners, although this could vary in type according to the needs of the parish. No attempt was made to reform these houses of correction and they became the forerunners of the workhouses.

The pillory, or stocks, were situated on gaol green in the Carfax, and were used as a punishment for such crimes as forgery, perjury, counterfeiting and libelling the Crown. Sometimes it went along with gaol, in that while doing time the prisoner would be taken to the pillory on market day and be manacled there for several hours to be abused by the townsfolk, sometimes wearing a paper hat saying what he or she had done. This punishment was abolished in 1837.

Another punishment would be whipping, and along with the pillory there was a whipping post on gaol green. The whipping could be specified as at the cart's tail, a more humiliating business of being whipped while tied behind a cart wheeled through the town. Whipping was for both men and women and was usually for minor thefts or vagrancy. The last whipping at the cart's tail was sentenced by Horsham Assizes as late as March 1805 for stealing wine. Branding on the cheek or hand was another nasty punishment, also sometimes combined with gaol. A combination of pain and shame was apparently thought to be a good deterrent. The current stocks and post on the Carfax are replicas made in 1991; the originals have been moved to the museum.

Sussex did not have many witchcraft trials, thankfully, unlike Essex and Kent, and many local trials ended in acquittal. The last one to be heard in Horsham Assizes was in 1680 when Alice Nash was charged with bewitching the youngster Elizabeth Slater and her sister. Elizabeth was two years old and clearly ill as she wasted away and died. Alice was acquitted and the witchcraft laws were repealed in 1736.

As early as 1666 a sentence in Horsham courts could be for transportation, be it seven or fourteen years or life. Initially this was to America until after the colony's independence in 1776 when, unsurprisingly, English convicts were not wanted. The destination then became Australia's penal colonies. Prisoners were held in old ships, or hulks, moored in the Thames until the transportation ships were ready to sail. Clearly the conditions on

board were not good and many did not survive the journey. Transportation was a harsh sentence as, if they survived the journey, the future was hard labour in a strange country far from home. In the early nineteenth century examples of those sentenced to this at Horsham, according to Albery in his *Millennium,* were Frederick Reader, fifteen years of age, who stole a watch with others, seven years transportation; Harriet Brown, nineteen, for stealing a basket and pocket watch, seven years transportation; and James Barnett, fifteen, for stealing a pocket handkerchief at the racecourse, transportation for life.

DID YOU KNOW?
A rather gruesome story of dissection followed the hanging on Horsham Common of Richard Grazemark, a labourer from Ferring who had murdered his daughter with whom he had had seven children. He was distraught that she had recently married and sat with the body before attempting suicide. After his execution in March 1790 and after an hour of hanging, his body was cut down and given to two young surgeons who were happy to have the public watch them at their work. The skin, which was very thick in parts, was given to a tanner to make leather, and the whole procedure, including the boiling of the bones, were open to public gaze.

At least these young people were not hung, which would have been very possible, and indeed Frederick Reader had received a reprieve from death to transportation. The gallows in the town were situated as near as possible to the gaol. Thus, when the first gaol was behind the Carfax on North Street the gallows were situated in Roffey, on the common as it was at that time, around a hundred yards from Champions Mill. The prisoners were put in an open cart, and with crowds of onlookers following, made the slow and awful drive to the execution site. A chaplain prayed for them, the hangman put the hanging rope around their neck and a cap over their eyes, and then the cart was sharply pulled away from under their feet. The body was left to hang for an hour before it was cut down and taken away, often for dissection before burial. Once the new model gaol was built in East Street, the gallows, or the Horsham Drop, moved out along the Brighton Road to a place near what is now Sandeman Way.

An extreme and unusual punishment was that of *Peine forte et dure*, or being pressed to death. The last case of this in England was in Horsham in 1735. The case involved a John Weekes of Fittleworth, who, with others, had broken into an isolated cottage near Petworth where a young woman, Elizabeth Symonds, lived with her mother. On the night in question Elizabeth's mother was away when Weekes, with others and using a young lad, broke into the cottage, murdered Elisabeth, ransacked the cottage and took what they wanted. Although Weekes could speak perfectly well, he refused to plead in court despite having had several opportunities to do so, and was therefore judged to be mute through malice. The sentence for this was that of being pressed to death. By not pleading, Weekes prevented his property from being confiscated after his execution, ensuring his family

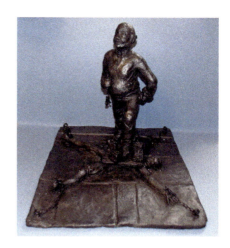

Model by Catherine Weekes of the punishment of pressing to death, displayed in Horsham Museum. (© Horsham Museum & Art Gallery (Horsham District Council))

would not be destitute. However, the death itself was horrible. He was spread-eagled on his back in the gaol's courtyard, arms and legs pinioned, and a large heavy board like a door placed on his chest. On this board was then placed iron weights of increasing size. He survived 350 pounds in weight but was clearly suffering, so the gaoler, weighing sixteen stone, then sat on him and finished him off. This was all open to public viewing.

Another sentence was burning at the stake, which continued until 1776 in Horsham. However, before the practice stopped there was a double execution of two women for the same crime, Ann Whale and her cousin Sarah Pledge. Ann was burnt and Sarah was hung. By this time burning was only for treason, and petit treason, the latter being especially for wives who killed their husbands. Both women were convicted of killing Ann's husband, James Whale.

As a teenager Ann had gone a bit wild after the death of her father but eventually, encouraged by her worried mother, she married a steady reliable labourer, James Whale. After living in a couple of local places they moved in with Ann's cousin, Sarah Pledge, her husband and seven children, the two families sharing the rented property. However, this seems to have been a little too close for comfort and arguments and petty jealousies arose. Sarah somehow persuaded Ann that she would be better off without James, and so the two women planned to kill him. First, Sarah found some spiders, baked them in beer, squeezed them out, and added them to James' beer. Not surprisingly this had no effect, except on the spiders. Next, she went to the local chemist and purchased poison, perhaps arsenic, telling them it was for the rats. Ann slipped this into poor James's hasty pudding, a porridge-like meal that he was fond of. The result this time was a swift and painful death. It was regarded locally as an act of God and he was buried without suspicion in St Mary's graveyard.

Later, Ann and Sarah's landlord called into the local chemist and the apothecary asked him if he had sorted out the rats, as Sarah Pledge had been in to the shop to buy poison for them. The landlord was puzzled and replied that he did not have a problem with rats, and slowly the men put two and two together. The women were arrested and confessed, Sarah also confessing to another murder that had not been discovered. After sentencing, Sarah was conveyed by cart to Broadbridge Heath where she was hung. Two hours later

her cousin Ann was tied to a stake, strangled, and a huge fire lit underneath her, which consumed her body very quickly.

The last burning in August 1776 was for another petit treason when eighty-year-old Ann Cruttenden killed her much younger husband and exposed his body to hungry cats who ate his nose and cheeks. She went the same way as Ann Whale, taken to the stake on a hurdle and strangled before burning. Her general behaviour was erratic and it was likely she was suffering from dementia. Men who killed their wives were of course hung not burnt.

A somewhat unusual crime, due to the size of the tax fraud and their apparent escape from due justice, was that committed by the Allen brothers in the mid-nineteenth century. From reports at the time it seems they had various malting houses throughout West Sussex, including Horsham, as well as three farms, and had grown wealthy from hiding the true extent of their business dealings from the tax man. Eventually, they were rumbled through a tip-off and fled to France, hotly pursued by the revenue men, but they cleverly doubled back to England, took a train up to Liverpool and hence to America, land of the free. It was estimated that they owed an accumulation of £375,000, built up over many years and a huge sum at the time. However, at their trial in absentia, one brother was fined £100,000 and the other £10,000. Eventually the Crown accepted a total of £10,000 from them, and they returned to Horsham, the past seemingly forgiven.

One cannot list every type of crime that Horsham dealt with, but smuggling should be mentioned. This was rife towards the end of the eighteenth and early nineteenth century when run-ins with excise officers often ended in violence, corruption of officials and appearances on the scaffold. War and a series of poor harvests contributed to the high price of wheat, which led to hunger and riot among the poor. Protests such as the Swing Riots and hayrick burning were punished on the scaffold, although some prisoners often engendered sympathy among the crowds. One such was the twenty-six-year-old Edmund Bushby, who was convicted of hayrick burning in the mobbing winter of 1830. As he hung on the gallows a robin persisted on perching on his shoulder and would not leave him. He was subsequently proved innocent when another man confessed on his death bed.

We have mentioned war and so must now turn to war and peace in the next and final chapter of *Secret Horsham*.

Portrait of Edmund Bushby.

Portrait of Edmund Bushby, reproduced from W. Albery's *A Millenium of Facts*, 1947. (© Horsham Museum & Art Gallery (Horsham District Council))

8. War and Peace

Since Norman times Horsham was fortified by three small castles, Channellsbrook to the north of the town, Sedgwick to the south and Knepp to the south west. These lesser castles saw mainly peaceful times, used for hunting parties and status, only Knepp suffered in war as we shall now see.

The Civil War

The mid-seventeenth-century English Civil War between the Royalists and the Parliamentarians, or Cavaliers and Roundheads, spread chaos, destruction and profound societal change throughout England, but Horsham remained relatively unscathed. Thomas Middleton MP, of Hill's Place, was officially a Parliamentarian, but was suspected of providing support for Royalist troops in 1643 during a Royalist rising in the town. He was arrested, released and then rearrested, but his family fortune had been made from the iron industry, which was now a target. Parliamentary troops destroyed the foundries in the forest, as mentioned in chapter four, as they were military assets for the Royalists.

Knepp Castle, 6 miles south-west of Horsham on the A24, was perceived to be another dangerous royal asset, as it was well fortified. The Parliamentary troops arrived on 19 July 1648. There was a minor battle at Bloody Field, south-east of the castle, and the Roundheads won. The old castle was then destroyed. It is said that much of the stone from the castle was subsequently taken to build the Horsham–Steyning road, in the eighteenth century. Only a single tower of the old castle remains, but another Gothic castle, designed by John Nash and built by Sir Charles Merrik Burrell in 1809, is the family home on the estate today.

Knepp Castle remains.

French and Napoleonic Wars

One tends to forget how many European wars there have been over the centuries, often with France in the enemy line-up. Horsham, in West Sussex and between the English Channel and London, was regarded as part of the front line of defence. Towards the end of the eighteenth century the Anglo-French, or Revolutionary, wars became increasingly difficult as coalitions with other European countries fell apart. So, the government planned to establish twenty-three barracks in Sussex, Horsham being the largest, costing £60,000 and housing up to 960 men. Not for the last time was there a real fear of invasion.

The barracks were built in 1797 on land rented out by landowner Nathaniel Tredcroft near, what is today, the Worthing Road and the cricket club. Today there is a footpath from the end of the Causeway, south and west along the edge of the cricket field towards the railway track, which retains the name Barrackfield Walk, with Barrack Field itself on the left. However, nothing now remains of the barracks on this site, which would have been on the right, built over by the cricket field and houses.

The first attempt at recruiting a volunteer corps came to nothing, despite several meetings, due to a lack of men of the right sort. It was suggested at the time that the volunteers were more attached to their beer than guns. However, after renewed fears of invasion in 1803 a second attempt brought in 120 men for the Horsham company, their officers being drawn from the local gentry, and the men drilled and inspected on the common.

Before the barracks were built, Horsham Common had been the camping ground for troops on the move. They camped there for a night, sometimes longer. With them were wives and wagons full of baggage. European regiments, allies against the French, were also accommodated, such as the 640 German soldiers whose conduct, as one would expect, was exemplary, whereas sadly some of the English soldiers' behaviour left a lot to be desired. Notorious were the 52nd Foot, who committed theft and burglary, including breaking into The Green Dragon, now the Olive Branch, and stealing £10. Bayonets appeared to be useful jemmies for breaking and entering!

Once the barracks were built Horsham became quite the military town, housing around sixty-nine regiments over the eighteen years it was operational, including the Australian 102nd regiment from New South Wales. Although the local publicans relished the money the soldiers brought to the town with their wages, there was often trouble, fights, drunkenness, mutinies and silly escapades.

Barrack Field and footpath.

DID YOU KNOW?
Richard Sharpe, a fictional soldier in Bernard Cornwell's historical fiction series of Sharpe, and played by Sean Bean in the 1990s television series *Sharpe*, was transferred as Second Lieutenant to the 95th Rifles. This rifle regiment, the 95th, was founded in Horsham in March 1800 under the name of the Experimental Corp of Riflemen and wore a distinctive dark green uniform.

In 1802 the Peace Treaty of Amiens brought the French wars to an end, with Britain conceding her overseas territories. However, Napoleon kept breaking the treaty conditions and still had ambitions to increase his empire. So, Britain declared war again after fourteen months of peace, and a military depot was built on Horsham Common, hence Depot Road today behind the station. It was very substantially built with high walls and contained an armoury full of weapons, quarters for the men and officers storerooms, workshops and an underground kitchen. After the Battle of Waterloo and the final victory over Napoleon in 1815, the barracks and the depot buildings had no further use and so were sold and later dismantled, the barracks going first in 1815. The wooden barracks guardhouse was moved by waggon to Charlwood, Surrey, where it was reused as a nonconformist chapel until recently. It has now been thoroughly restored and will be opening as a study centre for the local primary school and an exhibition space celebrating its history.

Also, on demolition, two of the three octagonal buildings used as the barrack cookhouses were bought at auction by Major Charles Beauclerk of Leonardslee, commanding officer of the northern division of Sussex Volunteers. One became an entrance lodge at Leonardslee Gardens, which can still be seen today on Brighton Road, and the other became an apple store in the gardens.

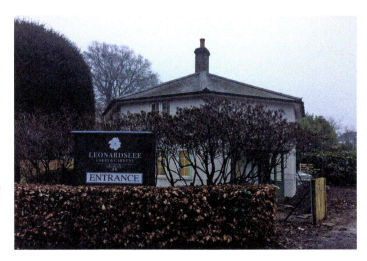

One of the three remaining octagonal cookhouses from the barracks, now the entrance lodge to Leonardslee Gardens.

Picture of Captain John Pilfold, hero of the Battle of Trafalgar, reproduced from J. Knight's *Horsham's History*, Vol 2, 2006. (© Pilfold family and Horsham Museum & Art Gallery (Horsham District Council))

Although some of the soldiers were disreputable, Horsham did have its own hero: Captain John Pilford, uncle on his mother's side to Percy Bysshe Shelley. He joined the navy at the age of thirteen and worked his way up until he took over command of HMS *Ajax* at short notice and took part in the Battle of Trafalgar. He was commended for his bravery and competence, eventually being awarded a gold medal, despite being not quite gentry.

One might think that Trafalgar Road, off Rushams Road, was named after the Battle of Trafalgar, particularly as it used to have a public house, demolished around fifteen years ago, called the Nelson. In fact, the road was named after Trafalgar House, a large property, brewhouse, coach house, stables and fields. However, it is probable that this house, built in 1819, was named after the battle.

There were peace celebrations in Horsham in August 1814, including a dinner, country dancing and a women's cricket match. However, this was all a bit previous, as Napoleon managed to escape imprisonment, although he was finally beaten the following year at the Battle of Waterloo.

The South African or Boer War

Unlike in the Napoleonic Wars, Sussex was not threatened by invasion in the Boer War, so the involvement of Horsham was marginal. It was the last war in which the British Empire was attempting to retain political and economic control of the Transvaal and Orange Free State in South Africa. These areas were rich in the natural resources of gold and diamonds. Sad to say the British, under Kitchener, operated a scorched earth policy with concentration camps, and it is estimated that 26,000 women and children died in these camps. Military casualties were high on both sides by the time it all came to an end in 1902. Although there is no memorial to the Horsham men that fought and died in this war, unlike the next two world wars, the war effort was supported by the town. For example, The Kings Head assembly rooms showed film scenes from the war at Christmas in 1900. Also, Brigadier-General Robert George Broadwood was honoured by the District Council for his military prowess, although later his command suffered an ambush and he lost 150 men.

The First and Second World Wars

On 4 August 1914 Britain declared war on Germany, following the German incursion into neutral Belgium. In the following few days there were calls by Lord Kitchener for men to volunteer to fight, and so began the First World War. Mobilisation of troops started immediately and Christ's Hospital School was commandeered for the detention of German prisoners of war, mainly naval at this early stage, and also for German nationals who were unable to make it back home in time.

The town responded quickly to being on a war footing, reviving the Boer War Patriotic Fund for the relief of families of servicemen. A volunteer civil guard was initiated and a large meeting held in the Carfax addressed by Earl Winterton to make a plea for political parties to unite and for local men to volunteer for either Kitchener's new army or the Sussex Territorial Regiment.

Another organisation that swung into action was the Qui Viva Corps, based above a shop at No. 60 West Street. It was founded in 1912 following the suffragette march held that year from Edinburgh to London to petition the prime minister on votes for women. Its purpose was as a centre coordinating marches through Sussex and for propaganda and activism in support of women's suffrage. It was based along military lines with uniforms and strict discipline, but was definitely non-militaristic in its activism. As war started it joined with other women's groups and used its organisational skills and office facilities to fundraise and collect fruit, sugar and jars for local jam making, which it then sent out, with other comforts, to soldiers on the front lines. Women ran the Horsham War Supply Depot based at No. 8 the Causeway, now a dental practice, which among other things sourced medical supplies and shipped them out to hospitals at the front. There was also the Women's Emergency Corps, which provided training in first aid, transport, signalling and other essential infrastructure. Although much of this work was voluntary, women did step in and fill other normally male roles, including long shifts at two of the engineering works in Horsham making armaments.

No. 60 West Street, site of suffragette and Qui Viva Corps offices.

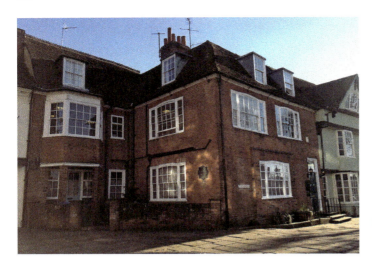

No. 8 the Causeway, site of Horsham War Supply Depot.

As in previous wars, perhaps one of the biggest impacts of the First World War on the town was the influx of young soldiers, with the establishment of Roffey Camp early on in the war. The camp stretched from the Norfolk Arms on Crawley Road back to Forest Road. Initially it housed the 22nd Battalion Fusiliers from Kensington, around 1,500 soldiers who came down from London. New huts were built and other regiments including Canadians and Portuguese came and went. Entertainment was provided and at first it seemed quite jolly, with all those interesting young men, but as the war dragged on the brutality and loss of life on the front became clearer, and news of Horsham's dead began to filter back, along with bodies.

DID YOU KNOW?
After the Napoleonic military depot was demolished in the 1950s the gate posts, which were made of two supposedly Napoleonic canons, were kept and became a garden feature in the new forest church rectory. Eventually they were given to Horsham Museum, who undertook some research on the 6 pounder guns and found that they were made for an earlier war in around 1717.

The Armistice with Germany was signed early on the 11 November 1918 and peace celebrations began the following year in June 1919. Thoughts also turned to ways of commemorating the war dead. In London Edwin Lutyens was commissioned to create the cenotaph for the mall, while in Horsham discussions began on making a permanent memorial. What would it be? It should be remembered that there was no precedent for memorials in town centres as we know them today. Suggestions ranged from a park, library, hall, or hospital to a sculpture or monument. Eventually a monument was decided upon,

but then it was a question of names; how would they be shown? Should they be just from Horsham town or the whole district? Finally, a large 17-foot-high obelisk on a wide-stepped base was unveiled in the Carfax in November 1921. This had the names of 359 war dead carved on plaques on the steps, which also carried an inscription. There were subsequent complaints about the weathering of the names, which were not easy to read, so the names were recut and set into a wall around the obelisk at eye height, as can be seen today.

A garden memorial was established later by Horsham's first woman counsellor, Nellie Vesta Laughton. She bought some land behind St Mary's Church by the Arun in 1925 and laid it out as a garden in memory of her husband who had just died, and also for those who had lost their lives in the war. It was Horsham's first official park and it has just been refurbished with new signage, improved paths and planting, and the addition of 7,000 daffodil bulbs.

In November 2018, on the centenary anniversary of the end of the First World War, at Poppy Field in Horsham Park, a memorial tree, a Sargent's Cherry, was planted by the chair of the British Legion, organised by New Friends of Horsham Park. Its bright red leaves in autumn and spring blossom represent loss and renewal.

The old Drill Hall, built in 1873 with club room and reading room, was originally in Park Street. The building itself was swept away a hundred years later by the development

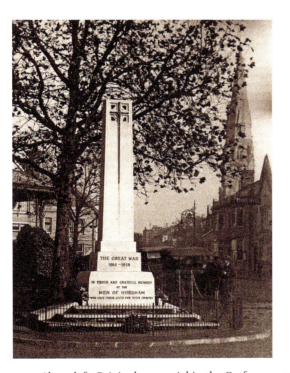 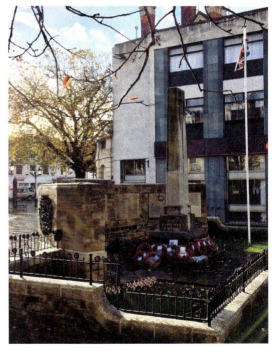

Above left: Original memorial in the Carfax, reproduced from J. Knight's *Horsham's History*, Vol 4, 2011. (© Horsham Museum & Art Gallery (Horsham District Council))

Above right: Today's war memorial in the Carfax.

of Piries Place, currently undergoing yet another redevelopment. It was the home of the 7th Sussex Volunteer Corps and it was built by their commanding officer, Captain Egerton Hubbard of Leonardslee. They were soon joined by the 4th Battalion, and when the First World War broke out they all volunteered for overseas service.

After the war in 1922 another commanding officer, Colonel J. R. Warren of the now 6th Battalion of the Royal Sussex Regiment, acquired a site on Denne Road and built a new spacious drill hall for the headquarters of the battalion. It was opened on the

The remembrance garden between the church and the Arun.

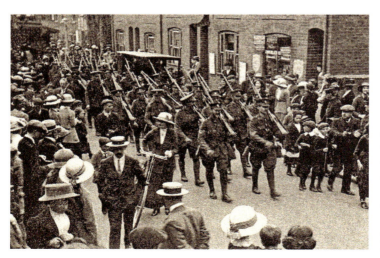

Royal Sussex Regiment, 4th Division, marching down Park Street in August 1914, reproduced from J. Knight's *Horsham's History*, Vol 4, 2011. (© Horsham Museum & Art Gallery (Horsham District Council))

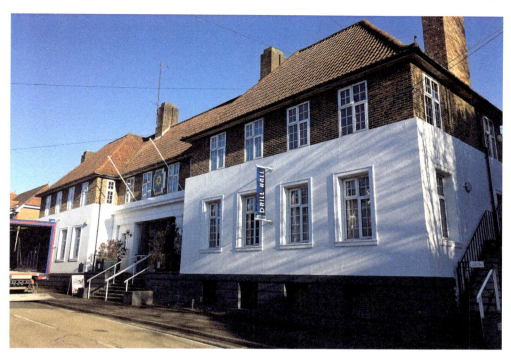

The Drill Hall, Denne Road.

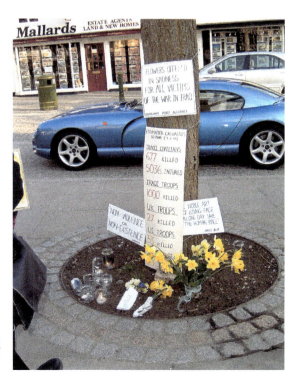

Anti-war protest on the Peace Tree in Carfax, 2003. (With kind permission of Alison Marshall)

23rd December 1927 and was designed to combine military and social needs. It had a large sprung dance floor in a hall that could be hired out, as well as facilities for military training and offices.

In the Second World War the Drill Hall was home to the Air Training Corps, together with two anti-aircraft guns. The Volunteer Observer Corps was based there in 1938, and renamed in 1941 to the Royal Observer Corps. They kept tabs on the movements of enemy aircraft and V1 rockets, which was vital work mainly done by women.

Due to the Drill Hall's continuing association with the military, there were anxieties about it becoming an IRA target during the troubles of the 1970s. However, the whole site was refurbished in the 1990s, then acquired by Horsham District Council and became the home not only of the local Air Training Corps but also a variety of community events.

There still remain in the town some elusive Second World War reminders of the defence of Horsham and the fear of invasion from the coast. Anti-tank ditches were dug connecting the rivers around Horsham, with pillboxes stationed along the banks to house machine guns with which to deter the invaders hoping to get to London. A chilling thought today. Around five of these concrete pillboxes remain, like that on the River Arun, west of Hills Farm Lane. Other less visible defences now are what were called dragon's teeth, which were large concrete pyramids sunk across roads in rows in order to stop invading tanks. After the war they were reduced to their foundations, although the sharp eyed can still see the remains on the Causeway, near the Museum.

Thankfully invasion did not happen, but there was a frightening bombing at Colgate in the forest. On the evening of 10 September 1940, a single German bomber circled the village three times and dropped five bombs. The first bomb was a direct hit on the house of the district nurse. She was dug out, only to be killed with her first aid helper by the next bomb that hit the village hall. Another bomb exploded at the churchyard gates, killing three auxiliary firemen who had been helping with the aftermath of the destruction. It seems to have been an inexplicable targeting of a civilian village, but there were military camps in the forest, so who knows what the young airman thought he was bombing.

Horsham residents became well aware of bombing raids on London as they saw the bombers go over, recognised the German engine noise, and saw the vapour trails during the Battle of Britain. Doodlebugs or V1 bombs came over regularly and bombs did occasionally fall on the town, such as on Orchard Road.

Again, in the Second World War there was an influx of soldiers camped in many of the large estates in the town, such as Canadians at Denne Park, Knepp and Leonardslee, and the Welsh at Newells. There were also Polish paratroopers who apparently sang as well as the Welsh when they marched. Later in the war there were the Italian prisoner-of-war camps at Coolhurst, the lovely woodland garden there being destroyed with huts and routeways. The Italian men made wooden toys and worked on the farms and were fondly remembered as being cheerful and friendly.

DID YOU KNOW?
On 10 August 1919 an unusual race took place from outside The Bedford Arms in Horsham. The champion runner, Alfred Shrub of Slinfold, ran a 5-mile race against a horse called Kitty. It was watched by 2,300 people and the horse won, but by only two minutes. Shrub was so good a runner that he had previously broken seven world records at the Ibrox track in Glasgow during one race. Ironically, his day job while an amateur was running a tobacconists shop in Horsham.

Those old enough to remember the 1950s and '60s will know about the Campaign for Nuclear Disarmament (CND) and their marches and actions, and later in the 1980s the Greenham Common Women's Peace Camp. Around this time the Horsham Peace Alliance formed from members of CND, the Labour Party, Quakers, United Reform Church and others. In 1986 they celebrated the United Nations Year of Peace by planting a False Acacia tree, with a plaque, in the Carfax. It can be seen today opposite Mallards, the estate agent. In the run-up to the 2003 Iraq War this tree became the focus for anti-war protesters. One hopes the need will not arise, but it could be such a focus again.

Poppy Field in Horsham Park and the newly planted remembrance tree.

In 1990 a peace garden was created in old Denne cemetery on Denne Road which dates from 1852. The peace garden is at the far end of the path through the old gravestones of the great and the good of Horsham. The Peace Garden contains plants from all the allied countries of the Second World War, reflecting the spirit of cooperation. These are at their best between May and August, spanning the dates of the victory in Europe and victory in Japan. A peace pole has been erected on the site with the prayer 'May Peace Prevail on Earth'.

Thus, with thoughts of peace rather than war, I end this account of secret Horsham. However, if your interest and curiosity has been aroused by reading this book, then do go to the museum and the library, as there are many more books and good information there. I have only touched on a brief selection of stories, people and events, which I hope you have enjoyed. I could not, of course, cover every secret story, so the rest is for you to discover.

Peace Garden in Denne Road old cemetery.

Bibliography

Albery, W. (ed.), *Reminiscences of Horsham being Recollections of Henry Burstow* (Norwood Editions, 1975)
Albery, W., *A Millennium of Facts in the History of Horsham and Sussex 947–1947* (Horsham: Horsham Museum Society, 1947)
Beswick, M., *Brickmaking in Sussex* (Midhurst: Middleton Press, 2001)
Birch, R., *Sussex Stones* (Horsham: Roger Birch, 2006)
Brandon, P. (ed.), *The South Saxons* (Chichester: Phillimore & Co. Ltd, 1978)
Brandon, P. *The Discovery of Sussex* (Andover: Phillimore & Co. Ltd, 2010)
Cadbury, D., *The Dinosaur Hunters* (London: Fourth Estate, 2001)
Djabri, S. C., *Images of England, Horsham* (Stroud: Tempus Publishing Limited, 2006)
Glover, J., *Sussex Place Names* (Newbury: Countryside Books, 1997)
Goffe, A., Hewell, N., Hurd, J., Stevens, S., *The Horsham Calendar of Crimes and Criminals* (Horsham: Horsham Museum Society, 2003)
Hare, C., *Historic Sussex, A Guide Book* (Worthing: Southern Heritage Books, 1998)
Horsham Museum, *Memories from a Town That Disappeared* (Horsham: Horsham Museum Society, 1989)
Hurst, D., *Horsham: Its History and Antiques* (London: William Macintosh, 1868)
Knight, J., *Horsham's History* Vol 1 Prehistory to 1790 AD (Horsham: Horsham District Council, 2006)
Knight, J., *Horsham's History* Vol 2 1790–1880 (Horsham: Horsham District Council, 2006)
Knight, J., *Horsham's History* Vol 3 1880–1913 (Horsham: Horsham District Council, 2008)
Knight, J., *Horsham's History* Vol 4 1914–1918 (Horsham: Horsham District Council, 2011)
Knight, J., *Horsham's History* Vol 5 Part 1 1919–1929 (Horsham: Horsham District Council, 2014)
Knight, J., *Horsham's History* Vol 5, Part 2 1930–1939 (Horsham: Horsham District Council, 2014)
Knight, J., & Semmens, J., *Horsham's Dragon* (Horsham: Horsham Museum Society, 2007)
Langton J., & Jones G., *Forests and Chases of England and Wales circa 1500–1850* (Oxford: St John's College Research Centre, 2005)
Lee, E., *Make Straight the Furrow* (Self-published, 1993)
Leslie, K., & Short, B. (eds), *An Historical Atlas of Sussex* (Chichester: Phillimore & Co. Ltd, 1999)
Lucas, E. V., *Highways and Byways in Sussex* (London: Macmillan and Co. Ltd, 1904)
Margetts, A., *Wealdbæra: Excavations at Wickhurst Green, Broadbridge Heath and the landscape of the West Central Weald* (Portslade: SpoilHeap Publications, Monograph 18, 2018)

Muggleton, D., *Brewing in West Sussex* (Stroud: Amberley Publishing, 2017)

Neale, K., *Victorian Horsham, The Diary of Henry Michell 1809–1874* (Chichester: Phillimore & Co. Ltd, 1975)

O'Leary, M., *Sussex Folk Tales* (Stroud: The History Press, 2013)

Poole, J. (ed.), *Reminiscences of Horsham: Recollections of Henry Burstow* (Horsham: Horsham Museum Society, 2016)

Short, B., *England's Landscape: The South East* (London: Collins, 2006)

Siney, A., 'Welsh Cattle at Horsham Market – Why?', *Horsham Heritage, 1 Spring 2000* (Horsham: Horsham Museum Society, 2000)

Thompson, E. P., *Customs in Common, Studies in Traditional Popular Culture* (New York: The New Press, 1993)

Tree, I., *Wilding* (London: Picador, 2018)

Wales, T., *A Treasury of Sussex Folklore* (Seaford: S B Publications, 2000)

Windrum A., *Horsham, An Historical Survey* (Chichester: Phillimore & Co. Ltd, 1978)

Wojtczak, H., *Women of Victorian Sussex* (Hastings: The Hastings Press, 2003)

Acknowledgements

Firstly, I would like to thank Jeremy Knight, Museum and Heritage Officer, of Horsham Museum and Art Gallery for his advice and support during this last year. Particular thanks must also go to Tom Aldridge and Alison Marshall who read through my efforts and gave really useful feedback. I would also like to thank all those friends in Horsham, old and new, who shared their stories, photographs and enthusiasm. Namely, the Lee family, Jonathan, Lindsey and Rowena, Bobby Vickery, Linda Lasham, David Codd, Leigh Ann Gale, Jane Duval, Chris Newton and Alex Newton, Julie Dumbrell, Liz Thorns, Chris Sleeman, Marilyn and Simon Quail, Tony Cocks, Chris O'Riordan, Martin Chick, Howard Malleson and all those in the Olive Leaves Book Club and Horsham Writing Circle. Thanks as ever to my good friends Rosalind Aldridge and Avril Bellinger for their endless support and encouragement.